F

The NAMES Project AIDS Memorial Quilt

A SELECTION OF PANELS CREATED

BY AND FOR INTERNATIONAL

FASHION DESIGNERS

Always
Remember

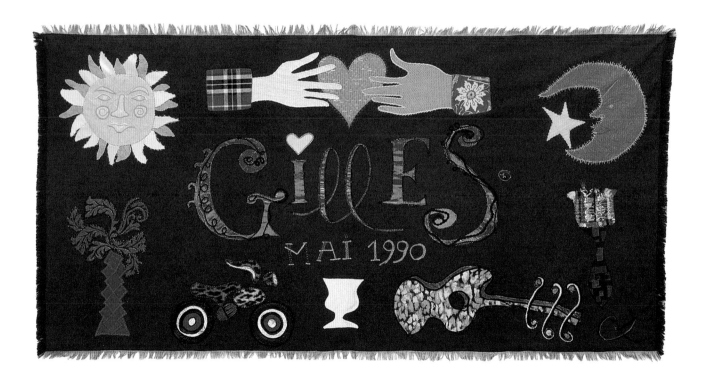

PHOTOGRAPHED BY PAUL MARGOLIES

Simon & Schuster Editions

A Fireside Book / Published by Simon & Schuster Inc. / New York London Toronto Sydney Tokyo Singapore

FIRESIDE
Rockefeller Center
1230 Avenue of the Americas
New York, NY 10020

FIRESIDE and colophon are registered trademarks
of Simon & Schuster Inc.

Designed by Katy Riegel

Manufactured in Hong Kong

1 3 5 7 9 10 8 6 4 2

Library of Congress Cataloging-in-Publication Data
Always remember : the NAMES Project AIDS memorial quilt : a selection
of panels created by and for international fashion designers /
photographed by Paul Margolies.
p. cm.
1. Fashion designers—Biography. 2. AIDS (Disease)—Patients—
Biography. 3. NAMES Project AIDS Memorial Quilt. I. Margolies,
Paul. II. Names Project.
TT505.A1A74 1996
362.1'969792'00922—dc20
[B] 96-24423
CIP

ISBN 0-684-82400-0

Acknowledgments

THIS VOLUME WOULD not have been possible without the remarkable efforts of Rifat Ozbek and Barton Friedland in Great Britain and of Traci Ann Macari, Jeff Thur, and the other volunteers of The NAMES Project/New York City chapter. Their passion and dedication to the project provided the energy and direction that allowed this collection of panels to be created. Early on, Annaliese Estrada and Marysia Woroniecka Publicity provided much-needed direction and assistance to the project.

Alastair Hume, Annie Provan, Ian Webb, and the other volunteers of The NAMES Project (UK) ensured that these panels would be an important part of the 1994 London display of the Quilt. Their contributions to that display and this book are considerable.

Particular note should be made of the efforts of photographer Paul Margolies, editorial consultant Tom Shepard, and NAMES Project Foundation staff members Juan-Carlos Castaño, Mike Smith, and James Robertson. They provided valuable insight and guidance to this project and applied their many talents to it with enthusiasm; the result speaks for itself. A special thank you also to Alan Purcell for his early photographic assistance.

Contents

Introduction

DURING THE FIRST WEEK of his freshman year at the Fashion Institute of Technology in New York City, Roberto Robledo met Larry Taylor. From that day in 1971 until Roberto's death from AIDS in 1993, Roberto and Larry were inseparable. Roberto was born in Colombia and had lived in Miami prior to moving to Manhattan to pursue his dream of becoming a successful fashion designer; Larry had been in the city since he was seventeen, having left the small-mindedness of his hometown for the excitement and promise of New York.

The 1970s was a rich and fertile time in New York for aspiring fashion designers. Glamour and innovation were the rule, and against this electric background Roberto and Larry thrived as friends, lovers, and students of couture and style. Roberto nurtured a lifelong fascination with unusual materials, often using industrial fabrics that had never before been sewn into clothing. On weekends, he and Larry would hit the discos dressed in outrageously colorful shirts that Roberto had spent the day sewing. By morning the shirts would be in tatters, but these daring creations were already helping to secure a reputation for Roberto in the competitive world of New York fashion.

In 1978, after working with a number of established designers, he founded his own company, Roberto Robledo. Although he and Larry were no longer lovers, they remained the best of friends and worked together closely in this new endeavor. When Roberto decided to relocate the company to San Francisco in 1982, he persuaded Larry to cancel his planned move to Japan and join him in California.

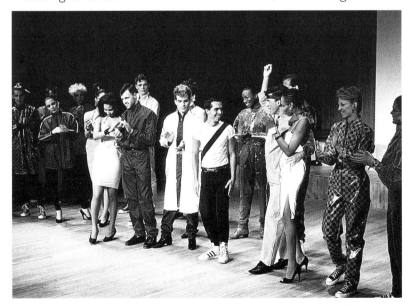

Roberto Robledo (center) *with models at the New York fashion show in 1979.*
PHOTO COURTESY LARRY TAYLOR

The previous year, Larry had spent his summer on Fire Island, as did many of his peers from Manhattan. He remembers that it was there he first became aware that something out of the ordinary was happening. The warm quiet of the island was interrupted every so often by the sound of helicopters. Yet another person had become sick with the "weird pneumonia" and needed to be flown off the island to a hospital in New York. Larry felt lucky because he didn't know anyone who was sick.

In 1988, Roberto tested positive for HIV, the virus that causes AIDS. Although he lived in San Francisco, a city that had been devastated by the epidemic from its very start, he decided to share his status with very few people, fearing that his business would be hurt by such a revelation. Larry became a guardian of this secret, and until the day Roberto died, he shared it with no one.

Roberto was not the only person in his company who was living with the disease, nor was his company alone in the epidemic. Across the country, the fashion industry was beginning to confront the immense impact of AIDS. Halston, Perry Ellis, and Willi Smith, three designers whose work and aesthetic sensibilities had shaped American fashion for many years, had succumbed to the disease by the end of 1990. Their names joined others as the fashion industry experienced the full force of this deadly plague. Make-up artists and models, photographers and pattern makers, sample makers and stylists were stricken by the epidemic that was now reaching into all walks of American life.

The shadow of AIDS had fallen and now stretched across the United States and the world. From the earliest days of the disease, the epidemic cast the city of San Francisco in a particularly horrific darkness. No area of the city was hit harder than the Castro district. Cleve Jones, a gay-rights activist and long-time resident of the area, remembers clearly the day in 1985 when he heard that a thousand San Franciscans had died, the vast majority of whom lived in his much-loved neighborhood. The horror of this statistic was made even more vivid when he tried to imagine the bodies laid out on the ground. Why did no one seem to care?

Later that year, as San Franciscans gathered to march in remembrance of assassinated Supervisor Harvey Milk and Mayor George Moscone, Jones, an organizer of the event, encouraged participants to write on colored poster board the names of people they had known who had died from AIDS. As the placards were taped to the Federal Building, Jones stood back to consider the results. He was struck by how this wall of names looked very much like a quilt. Over the next months, he could not get this image out of his mind, and by 1987, the NAMES Project AIDS Memorial Quilt was born.

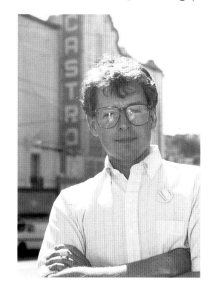

Cleve Jones, founder of the Quilt, in San Francisco's Castro district in 1988.

Composed of individual three-by-six-foot panels, each made in memory of someone lost to AIDS, the Quilt touched a nerve. People from all over the country and the world at last had an

opportunity to express their grief and anger about the epidemic. In October 1987, when the Quilt made its first appearance on the Mall in Washington, D.C., almost two thousand panels had become part of this memorial. As the epidemic's toll continues to mount, so grows the Quilt. By 1995, the Quilt included more than thirty-two thousand panels, a number equal to only 11 percent of the Americans lost to AIDS.

For many, the act of making a panel for the Quilt has become a rite of remembrance, of acceptance, and of making a public statement. Families gather in homes to sew their memories into this enormous Quilt. Parishioners stay after church on a Sunday afternoon to create a contribution for the Quilt in memory of not just one from their congregation but twenty. Co-workers spend their lunch hours recalling a friend's smile and planning his panel.

Completed panels are sent to The NAMES Project's national headquarters in San Francisco. With great care, each is checked, reinforced as necessary, and then sewn with seven other panels into twelve-foot-by-twelve-foot sections. The Quilt is stored in a warehouse space, the size of which tells a sad fact of the enormity of this epidemic. Stacked on shelves that run ceiling to floor in an old industrial building, the Quilt sections await an opportunity to be unfolded to tell their stories of love and loss.

On display in Washington, against the backdrop of the Capitol and the Washington Monument, the Quilt became a symbol of a government's inaction and ignorance. Laid out in a city of monuments remembering the dead of other conflicts, the acres of fabric that are the Quilt bore witness to a war that rages in the bodies of its citizenry. Almost a decade after its first display, the Quilt continues to serve as more than a simple memorial; displays of the Quilt have proved exceptionally effective as catalysts for education and change.

The alarming rate of HIV infection among people under twenty-five years of age has led to the mobilization of the Quilt as a potent tool in HIV prevention education. In schools across the United States, the Quilt augments local education programs, eloquently and effectively underscoring the humanity behind the statistics that have become a numbing mantra in any discussion about AIDS. The vast majority of high school students who see the Quilt report that the experience has made them assess their

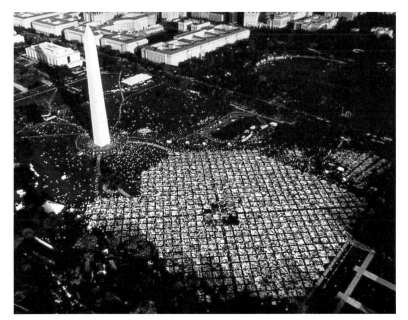

When the Quilt was first displayed in 1987, there were 1,920 panels. Five years later (above), there were 20,064 panels on the grounds of the October 1992 display in Washington, D.C.

own risks and take measures to protect themselves. In a war against a disease that has no cure and for which prevention is our best hope, the Quilt has emerged not only as the symbol of what has been lost but also as a weapon that can hasten the end of this plague.

Early in 1993, Rifat Ozbek, two-time recipient of the British Designer of the Year Award, began to approach his fellow designers with the idea that they each create a panel for the Quilt. Rifat's years in fashion had left him no stranger to AIDS, and as a clothes designer, fabric was certainly a subject of considerable interest to him. Rifat's friend Barton Friedland had participated in the 1992 international display of the Quilt in Washington, D.C., and witnessed the incredible power of the Quilt firsthand. The experience of viewing the more than 20,000 Quilt panels from around the world had a profound effect on Barton. The Quilt seemed like a natural way for the fashion world to make a statement about the disease. Soon Rifat and Barton were hard at work encouraging their colleagues to join them in this effort.

Across the Atlantic, unbeknownst to Rifat and Barton, The NAMES Project/New York City chapter had begun to approach designers with a similar idea. When it became clear that the goals for the two projects were so similar, they joined forces. As it had before, the Quilt struck a nerve; soon designers from around the world were sending their creations to be part of the Quilt.

In June 1994, London's Hyde Park was the site of Quilts of Love, a display of the International AIDS Memorial Quilt, organized by The NAMES Project (UK) as the focal point of their efforts to help raise awareness about HIV and AIDS in Britain. As part of the display, sixty-four of the panels remembering those lost by the fashion industry were unveiled for the first time. Articles in *Vogue* and *Interview,* among other publications, celebrated this remarkable collection and the solidarity of the fashion industry against the horror of AIDS.

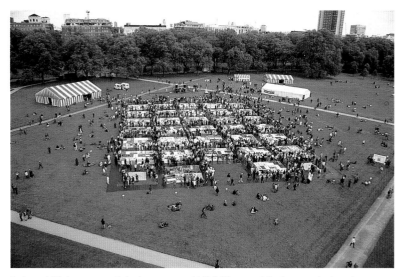

In June 1994, sections of the International AIDS Memorial Quilt were displayed in London's Hyde Park. The display included sixty-four panels made by international fashion designers.

In San Francisco, Larry Taylor had been asked to make a panel for his beloved Roberto, a challenge he put off for many months. The task made him think grimly of his childhood in the Northeast and of the grave blankets that had covered the plots in cemeter-

ies during the winter. He knew that making the panel would force him at last to admit to himself that Roberto was really dead. After months of hesitancy, he sat down and in a few intense days crafted a panel in memory of Roberto.

Making the panel was a watershed experience for Larry. It allowed him to fully understand that his best friend was gone. It also gave him something he had not expected; in letting go, he found the strength to move on. Roberto had left him in control of the company, and the responsibility for this venture was not something Larry took lightly. For the first time since Roberto's death, he knew he could take charge and, even without Roberto's unique creative vision, the enterprise would continue.

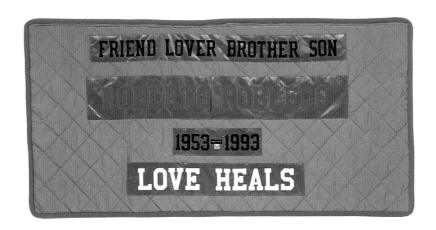

Panel for Roberto Robledo made by Larry Taylor.
PHOTO BY PAUL MARGOLIES; COURTESY THE NAMES PROJECT FOUNDATION

Larry's eyes still well up when he remembers Roberto. Until the end, Roberto fought the disease. Even three days before he died, Roberto was at work putting finishing touches on his next collection. Though the pain was unbearable, his will was even stronger. Roberto Robledo lives on in Larry Taylor. When Larry made the Quilt panel for Roberto, he discovered this strength, a lasting legacy of his greatest friendship.

The AIDS Memorial Quilt is pieced together with the love of thousands of panelmakers. These efforts have created a rich and diverse tapestry of the lives cut short by this devastating disease—ordinary people and superstars of all races, creeds, sexual orientations, and political beliefs—sewn side by side and held together by a single, shared fate. Most panelmakers have chosen to

remember the losses closest to them, while others have memorialized people who have touched their lives in other ways. Every panel is welcomed into this fellowship.

Since its inception, the Quilt has included memorials for people from the fashion industry who have succumbed to the disease. Made by colleagues, relatives, and often even strangers, five of these panels, each with an accompanying text, are presented in this volume scattered among the panels made by fashion designers. By no means a comprehensive review of the impact of AIDS on the world of fashion, they provide glimpses into the broader context of the epidemic and its cultural toll.

This book presents a unique opportunity to view the collective effort of one community to remember lives that have been lost to AIDS. This collection of panels will soon be dispersed into the Quilt, to stand alongside others as a record of our loss. Just as a company or place of worship might create panels in memory of colleagues or congregants, the fashion industry decided to create panels for the Quilt to help the world better understand the awful human cost of this disease. The panels shown in this book represent only a fraction of a Quilt that now covers thirteen acres. Like so many others, these panels tell the stories of this epidemic. The NAMES Project is honored to accept them into the AIDS Memorial Quilt.

And still the Quilt grows.

—Anthony Turney
Executive Director
The NAMES Project Foundation
1995

F a s h i o n ' s P a n e l s

The panels that follow are a collaborative project of a spectrum of fashion designers who created panels for friends, colleagues, and lovers lost to AIDS. Each panel, whether vertical or horizontal, measures approximately three feet by six feet and is identified by company name and country of origin as well as a statement by one or more people involved in making it. Interspersed among the panels made specifically for this international project are five other panels memorializing several figures from the fashion community. They are among the many in the Quilt that commemorate the losses of this industry to AIDS.

Giorgio Armani

(Italy)

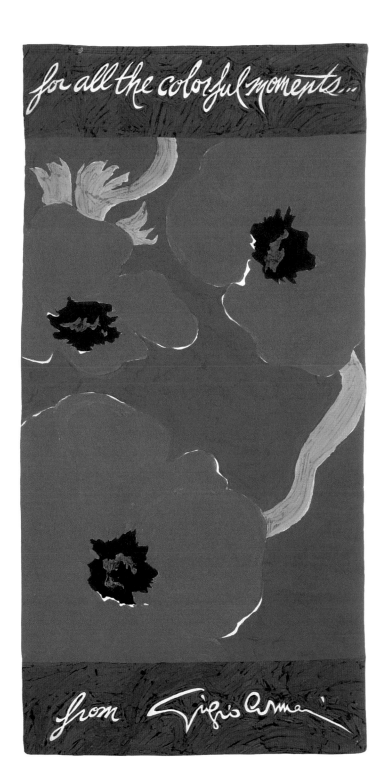

In memory of those who have died of AIDS

This extraordinary fabric, woven of heartache and hope, speaks of emotions and memories beyond words.

GIORGIO ARMANI / DESIGNER

Jeff Banks

(UK)

In memory of James

All the world's a stage
And all the men and women merely players.
They have their exits and their entrances
And one man in his life plays many parts.

—William Shakespeare, *As You Like It*

James McClousky played many parts and will doubtless make many more entrances.

JEFF BANKS / DESIGNER

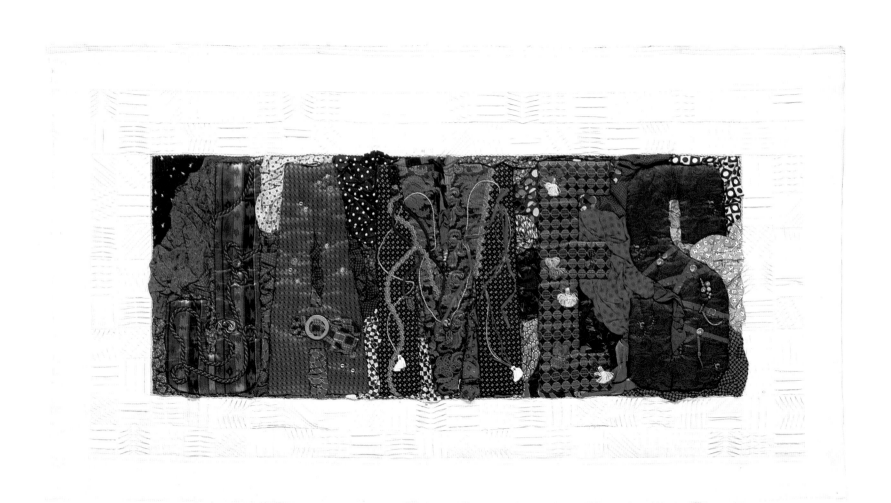

B.C.B.G.

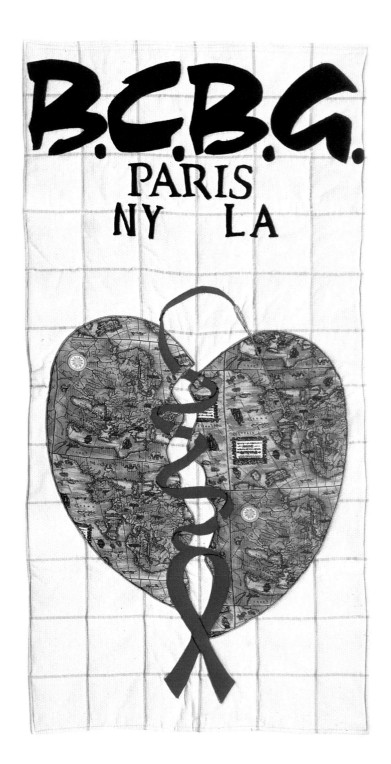

In memory of those who have died of AIDS

For a unified planet brought together by memories of those lost to AIDS, B.C.B.G. dedicates this panel to the lingering impact and the great losses to the fashion world.

The red thread creates hope in a world shattered by AIDS. It will unite us as one in the ongoing battle.

LUBOV AZRIA / DESIGNER

Geoffrey Beene

(USA)

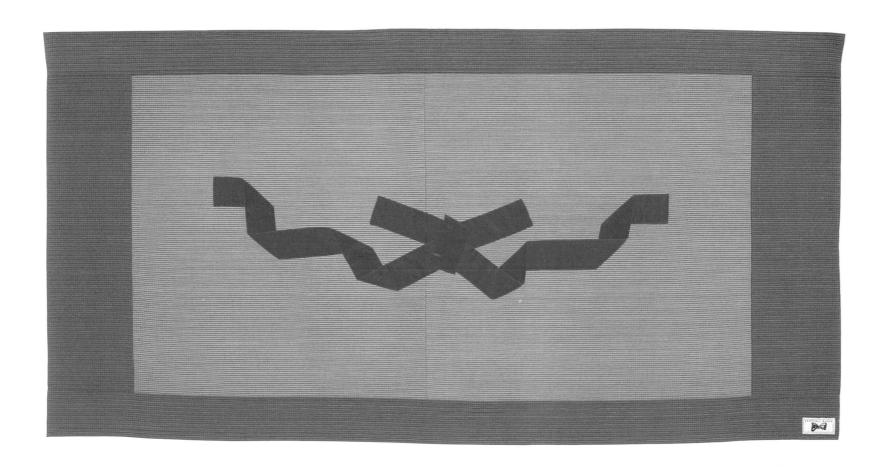

In memory of those who have died of AIDS

Like any gift to cherished ones—it is wrapped and tied with a bow.

GEOFFREY BEENE / DESIGNER

Russell Bennett

(USA)

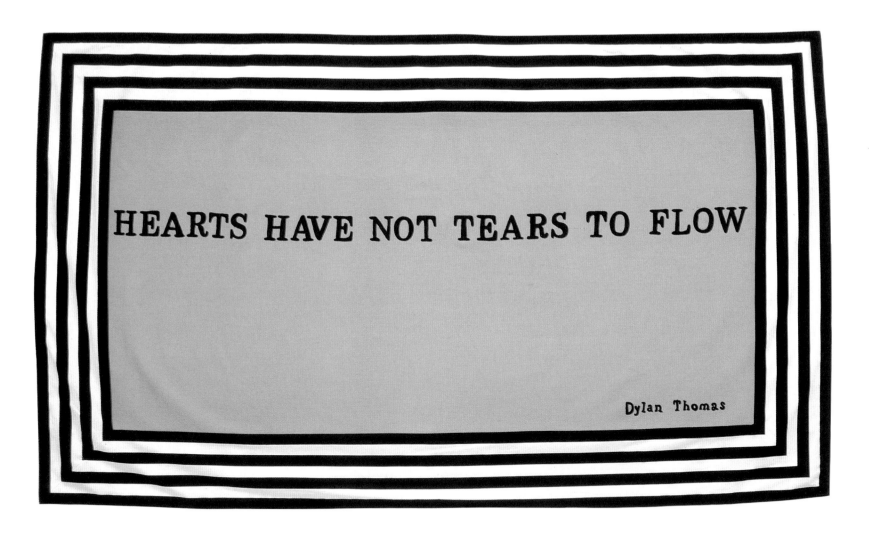

In memory of Alberto Cintron, Frank Silano, Todd Mucaro, Franco Moschino

This panel was made not only for the personal losses but for everyone who has lost anyone to this disease; for the holes left in lives that can't be refilled; and for the compassion of and for those who have to be left behind.

Life is good. Hope is eternal.

RUSSELL BENNETT / DESIGNER

Bill Blass

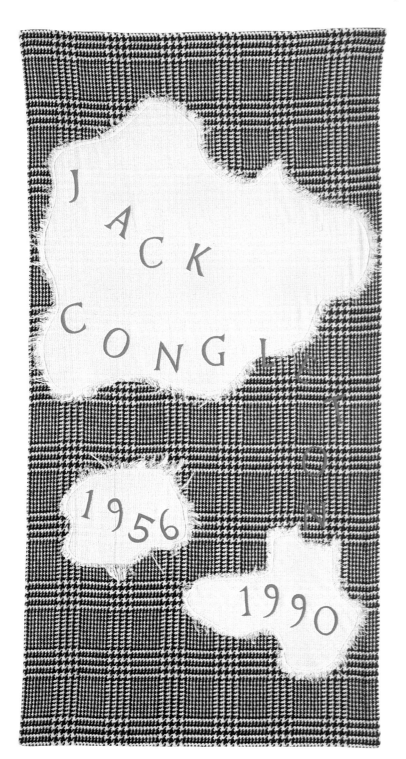

In memory of Jack Congleton

In putting together the panel, this project became an informal collaboration of people at Bill Blass Ltd. who knew Jack Congleton as an employee, a co-worker, but most especially as a friend. People made suggestions for the panel and offered stories about Jack and how he touched their lives. Jack was an integral part of our organization in his capacity as an account executive. One person remembered Jack for his sense of humor—albeit even a little wicked at times. Another person spoke of Jack's easy elegance—both in dress and general air. To remember Jack is also to remember his devoted black Labrador, Tyler, who at times accompanied Jack to the office.

Truly, of all the remembrances of Jack, the quintessential memory is of him and his companion, Joseph. Joseph lost his battle with AIDS a number of months before Jack became ill. However, until the end, Jack cared for Joseph with great love and tenderness.

Let it be said that Jack Congleton's loss is great both to family and friends. It is our sincere hope that his memory will blaze brightly with this panel for the world to know him as we knew him.

BILL BLASS / DESIGNER

Bruto/Colonna

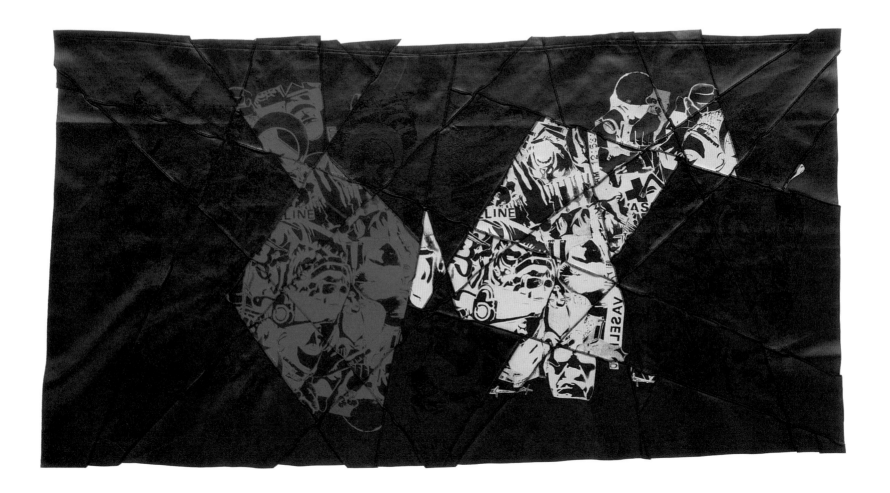

In memory of those who have died of AIDS

I made this panel in memory of lost innocence. When I did it, I tried to express the consequences of losing a loved one to AIDS for the person who remains. Adding to the emptiness and helplessness, there are the scars, the marks, the pieces of a shared life that you try to put back together again like a broken mirror, to reconstruct the present, without ever forgetting.

JEAN COLONNA / DESIGNER

Joe Casely-Hayford

(UK)

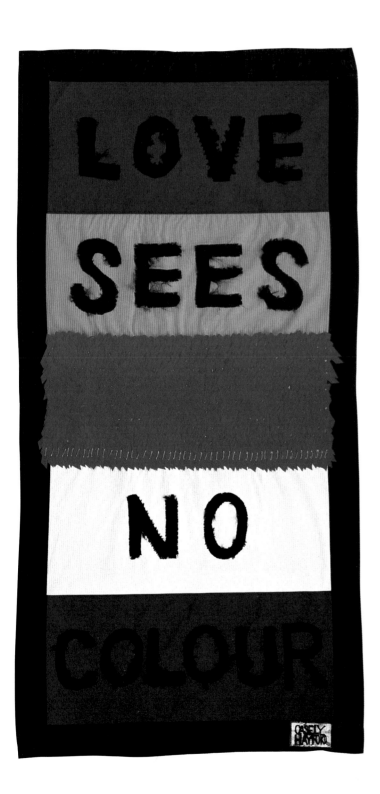

In memory of those who have died of AIDS

The idea behind my panel is to show that all life is sacred, whether it be someone living in an isolated part of Africa or a high-profile celebrity. Equal respect and support are essential. This panel is not dedicated to anyone specific, but to all those who have died anonymously.

JOE CASELY-HAYFORD / DESIGNER

Oscar de la Renta

(USA)

In memory of friends

For two of my most beloved friends—Andre Oliver and Kim d'Estanville. Both were extremely talented, with a great love of life. We have lost so many talented people in our industry.

OSCAR DE LA RENTA / DESIGNER

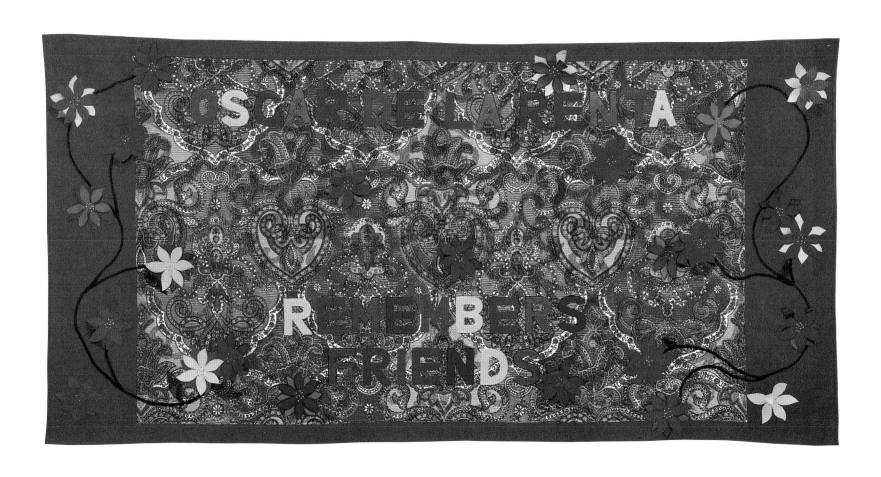

Ben de Lisi

(UK)

In memory of Hans Lutkehaus

Hans Lutkehaus was the best friend and mentor of my lover, Jean-Louis Journade. I met Hans through Jean-Louis and began to see why he meant so much to him. I, too, grew to love Hans and benefit from his rough charm, kindness, and unending generosity. He was always there for both of us, and he was singularly the most instrumental in helping us start up our lives together here in England.

This silver-haired man was a true friend under all circumstances. He gave of himself freely and unconditionally. He never tired and always joked. He nurtured and nourished us and gave us options that were and are rarely available. To say we loved him would be an understatement. To say we needed him would be obvious. To say we miss him . . . we will always miss him.

He was a knight in shining armour.

He was that comfortable uncle.

He was our big brother.

Now he remains our angel.

Fly high, friend—enjoy the soft air, warm sun, and rest amongst slivers of the moon.

BEN DE LISI / DESIGNER

JEAN-LOUIS JOURNADE / PANELMAKER

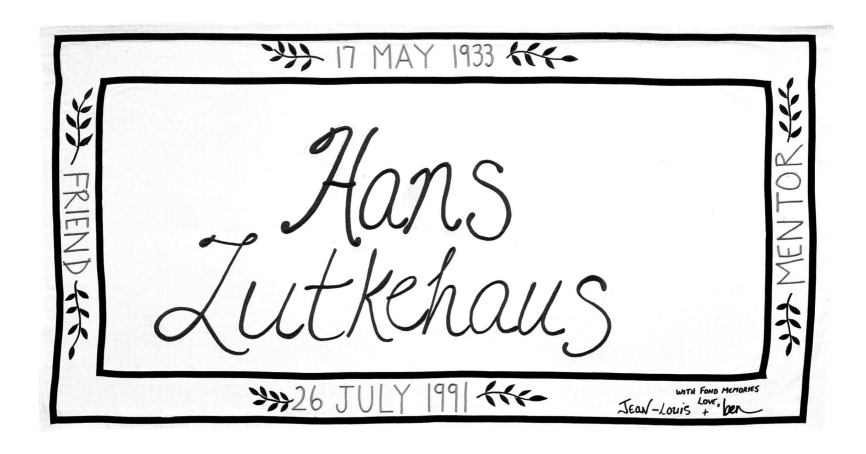

Ann Demeulemeester

(Belgium)

In memory of Robert Mapplethorpe

When I first met Robert in New York, I gave him a card with my name and telephone number. He said he didn't have a card but he intended to have one printed: a black card with a little hole in the middle. "I like that very much," he said. That's why I made a black memorial panel with a hole in the middle.

Robert, true art is always sincere. That is one of the things you showed me. Thank you.

PATRICK ROBYN / DESIGNER

Robert, you and Patti inspired our work and lives in a way that I cannot put into words. Thank you for your intense life.

ANN DEMEULEMEESTER / DESIGNER

ROBERT

Dolce & Gabbana

(Italy)

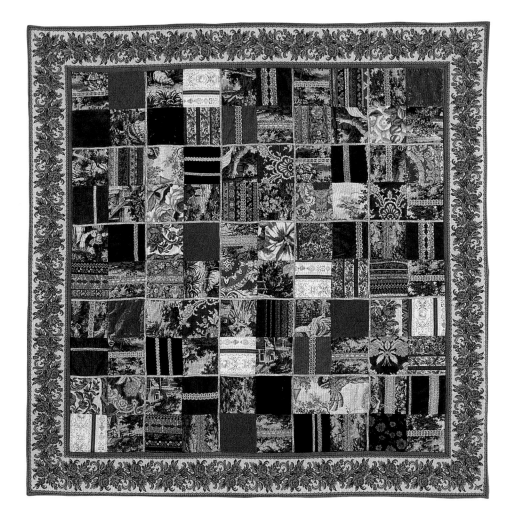

To everyone who has died of AIDS

The quilt is a patchwork of many different materials, fabrics, and colors, and although each piece is extremely different from the other, they are joined together in perfect harmony. It is a symbolic representation of the union of many different people from different worlds, united in one sole desire: to defeat AIDS.

We believe that this union helps everyone battle a common evil more effectively, and that unconditionally, it brings with it an awareness of what is the new plague of the twenty-first century.

DOMENICO DOLCE / STEFANO GABBANA / DESIGNERS

Mark Eisen

(USA)

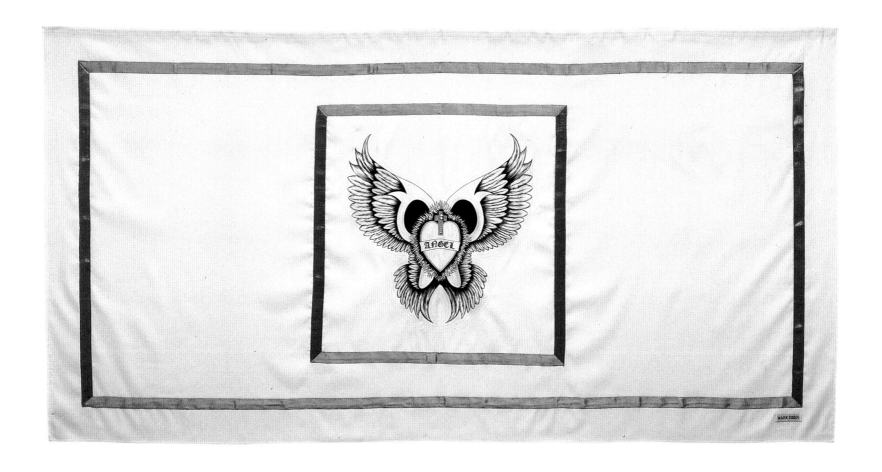

In memory of those who have died of AIDS

There were so many courageous individuals who needed to be remembered. Some we never met, but even in their anonymity we knew they were heroes. So to all of them we dedicated this panel. As angels we know they will return to protect and offer hope to all of us.

THE TEAM AT MARK EISEN

For Perry Ellis

(USA)

In memory of Perry Ellis

This purple panel for Perry Ellis symbolizes the strong spirit and the exceptional creative force that filled his life.

The size of his name in relation to the size of the panel represents his fear in dealing with this disease openly.

It also represents his subtlety and shows how powerful understatement can be.

PAT COOL / PANELMAKER

Gianfranco Ferré

(Italy)

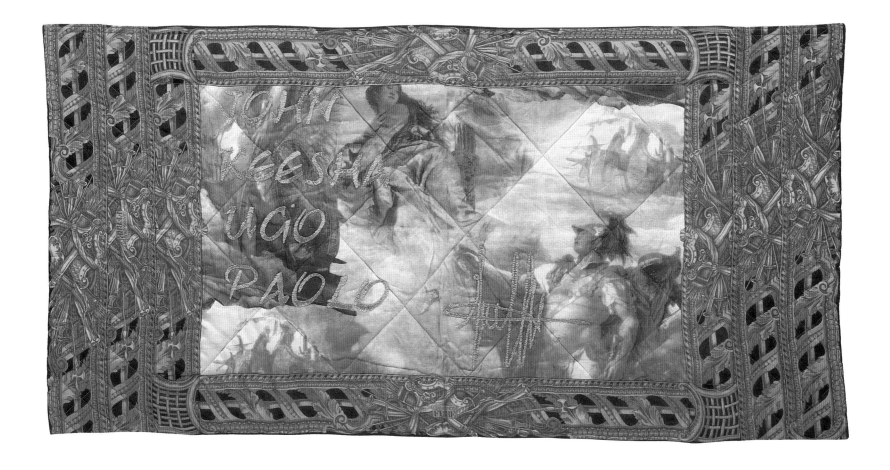

In memory of John, Keesha, Ugo, and Paolo

AIDS is a terrible disease. Before striking down the victim, it deprives the person of what makes human existence wonderful and unique—tenderness, beauty, and passion. AIDS is a terrible disease, but, although still without a cure, becomes less puzzling every day. Thus there must be no sense of resignation in dealing with it. Rather, we must fight the battle through education, awareness, and courage. This is what I had in mind in creating my quilt panel: to bear witness through my work to the serenity of a memory, many fond memories.

For each man is alive as long as he lives in the memory of those who knew and loved him, sharing with him a deep affection for the extraordinary adventure of life.

GIANFRANCO FERRÉ / DESIGNER

Ferretti

Dedicated to Ed Riley

I met Ed Riley in August 1978, just a few weeks after both of us had arrived in New York, he from Albany, Georgia, via Paris and I from Berkeley, California.

We were both fresh-faced, filled with enthusiasm, and ready to conquer New York, if not the world. We were thrown together by mutual friends, and both shared a great love of fashion.

Ed went to work for Halston while I worked for a series of smaller designers. He often invited me to the Olympic Towers where he worked and where all the beautiful people came to visit and view the Halston collections. Many years later we came to work together and forged a strong business relationship as well as an extremely close personal friendship.

Ed was my best friend and my closest colleague for over ten years. I cannot easily put into words the impact he had on my life. He made me laugh every single day I knew him until the day of his death. Communication between us was not limited to words or gestures—we could communicate with a glance or the blink of an eye. I still cannot accept the fact that Ed is not here. His presence is indelible in my memory and in my daily life. How could such a beautiful spirit be extinguished in such an unnecessary way in the prime of his life? I carry on, having gathered much strength from Ed and having learned many lessons from him—above all the lessons of love, patience, and forgiveness, which he gave to me so many times throughout our life together.

MICHELLE STEIN
DIRECTOR OF THE NEW YORK OFFICE FOR ALBERTA FERRETTI

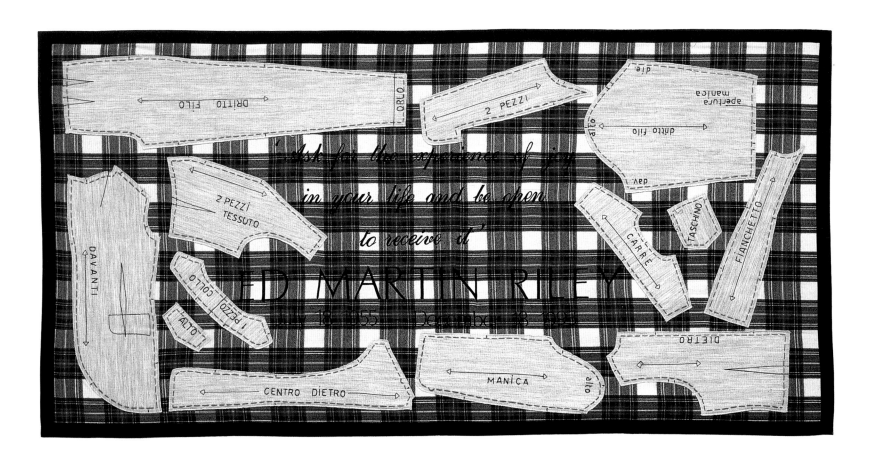

Force One

In memory of those who have died of AIDS

When I decided to create a panel for the AIDS Memorial Quilt, I wasn't prepared for the range and intensity of emotions that would go into making it.

I recalled the faces of friends and colleagues who had died. I thought of the people they had left behind, their mothers and fathers, wives and husbands, sisters and brothers, sons and daughters, lovers and friends. Were they devastated at saying good-bye, or did they take comfort in knowing that their loved ones' suffering had ended? I think both were probably true.

I felt anger and disappointment at the ignorance and prejudice that surrounds this disease and at a government whose policy seems to be not enough, too little, too late. I felt hopeless: When will a cure be found? How many more will die?

I thought of my wife, Dori, and my son, Devon. I thank God they are healthy and happy. Will my son grow up in the "age of AIDS"? I hope he will not have to, but if he does, I hope he will possess the wisdom and compassion needed to deal with this disease.

I thought proudly of the thousands of people who live with HIV and AIDS and who face its difficulties with dignity and courage. And I was proud of the thousands of people who fight this disease in other ways — those who work for AIDS organizations to provide services for the infected, the medical professionals who care for the sick and search for a cure, those who dedicate their time and their money to charities, and those who seek to raise awareness and educate the public. I dedicate this panel to every one of them. Thank you.

DAVID DART / DESIGNER

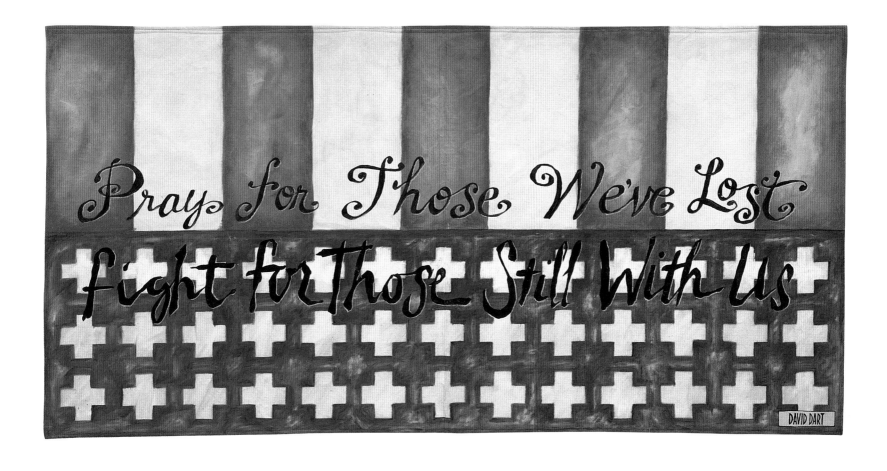

Bella Freud

In memory of Robert Fraser

The first time I met Robert Fraser, he was so rude to me I could hardly believe my ears. He was often rude to people, but he did it with such panache that he got away with it. In spite of his initial harsh treatment of me, I couldn't help liking him. He was so funny and irreverent, and I loved his perverse point of view. We soon became friends, and I hoped he would become a great friend, but there wasn't time. He died in 1986 while I was living abroad.

Robert was a great instigator of things good and bad. His antics were always extreme, sometimes appalling, but he had a winning quality about him, like the glamorous one at school, which made it thrilling to be in his company.

In especially absurd or poignant situations, I often think of Robert and wish he were there.

BELLA FREUD / DESIGNER

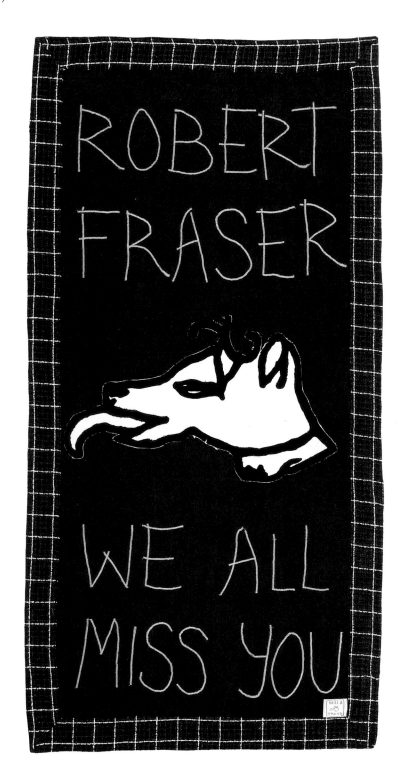

Ghost, Ltd.

(UK)

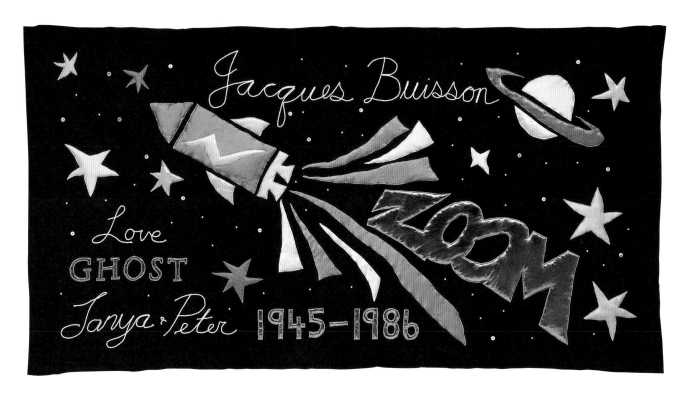

In memory of Jacques Buisson

Jacques Buisson was born in Paris in 1945. He was a style leader and was one of the first to bring French and English fashion to Germany, where he built up a thriving fashion distribution business during the seventies and early eighties. He encouraged and helped me to set up Ghost and gave Ghost its first substantial export order—well in excess of the collection's worth. He was a larger-than-life person—warm, emotional, sensitive, caring, and fun. He was the best kind of friend and will not be forgotten.

Dearest Jacques:

How can I thank you for becoming the brother and sister I never had? How can I ever hope to repay your enormous generosity to me in both my personal and business life? Without you, and all the others who have given their lives, the world has become a sadder, poorer, place. I hope the Zoom quilt (your company name) reflects the dynamism and razzmatazz you put into life. No matter *WHAT*, I will never understand *WHY*.

I miss you and will always love you.

TANYA SARNE / DESIGNER

For Gia

(USA)

In memory of Gia

What empowered me to make panels for Gia and others is my love for people with AIDS and their families. Until there are no more names, I will weep tears filled with that love. Until there are no more names, I will educate the ignorant and march with my candle held high. Together we will march for our lovers, our parents, our children, our sisters, and our brothers, until there are no more names.

To Gia, with love. Thanks for touching all our hearts.

DONNA WOOD / PANELMAKER

GUESS?, Inc.

(USA)

In memory of Antony Moorcroft

My best friend passed away. His name was Antony Moorcroft, and he died of AIDS four years ago. The panel I designed on GUESS?'s behalf is dedicated to Antony.

It is utterly impossible to describe how I feel about losing him and how deeply he is missed. I think about him every minute of every day. I loved him very much.

We shared so much, especially our passion for fashion design. He was my biggest fan and supporter, my creative sounding board, my guiding light and mentor, and I was his. When I think about the beautiful and pure connection we shared, it is no wonder to me that I have not been able to share this with anyone since his passing.

When I was approached to design this panel on behalf of GUESS? I realized there was no better way to honor and commemorate Antony. GUESS? has been and continues to be a huge supporter and fund-raiser for several organizations that strive to find the cure for this horrifying disease. I think Antony would be really proud of this work and the fact that I have helped in the best way I know to be part of it.

ANGIE FURLONG / DESIGNER

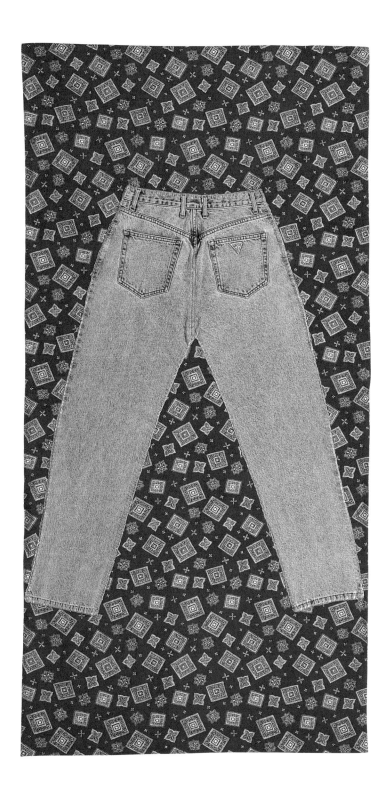

For Halston

(USA)

In memory of Halston

I was about ten years old when I saw the name Halston for the first time. The name was on the package of my mother's new perfume. The bottle was oddly shaped, very different from her other perfume bottles.

I was already starting to dream about being a fashion designer, and I became more and more aware of Halston through my mom's fashion magazines and the gossip columns. He was the *enfant terrible* of the seventies fashion scene in New York.

For a young boy growing up in South America, Halston and his group of cronies represented all the glamour and success that the fashion world could bring. Years later I moved to New York and saw Halston several times at Studio 54. By then, the Halston dream had started to crack, but he remained as handsome and elegant as ever.

Halston had shown American women, and women the world over, that glamour was not exclusive to the rich. He made his name into an empire and then gave it up. I remember the headlines about "the man who sold his name to 7th Avenue."

I think, above all, Halston was a human being capable of great achievements as well as great mistakes. And through it all he lived his life with the gusto of those who know a good thing when they see it.

Halston died in March 1990, in a San Francisco hospital. He was 57 years old.

For his panel I've used a silk-screen of an ad that ran in *Harper's Bazaar* in 1974. It shows the portrait of Halston by Andy Warhol, and I copied it from a print proof a friend of mine bought at the Halston estate auction in San Francisco. The panel is made of Ultrasuede, a fabric Halston made very popular and was his signature fabric. Its color, brown, reminds me of the Halston Z-14 cologne package that I got as a present on my thirteenth birthday.

Halston's name still spells magic and glamour to me. It stands as the legacy of a man who, more than anything else, loved life and tried to live it to the fullest. He will always be remembered.

JUAN-CARLOS CASTAÑO / PANELMAKER

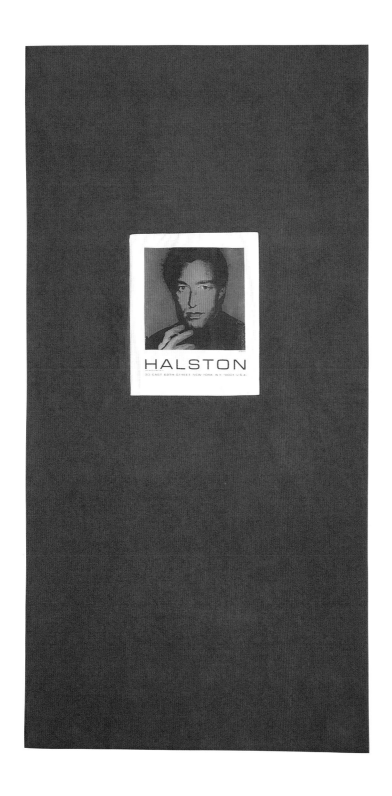

Katharine Hamnett

(UK)

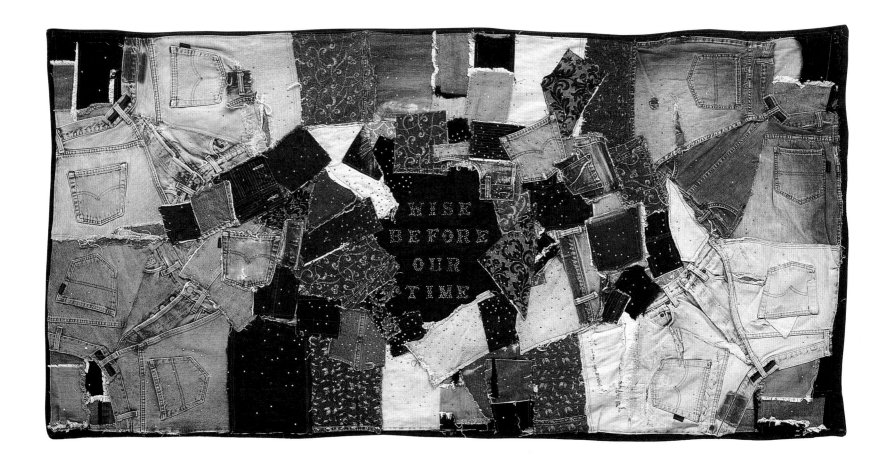

In memory of those who have died of AIDS

This is to symbolize the way we all are living today. We have had to "wise up," not take anything for granted anymore. We have all had to bear the consequences of HIV and AIDS in some way—from the death and illness of friends and colleagues, the constant documentation of its worldwide ravages through the media, to the everyday necessity for safer sex. This panel commemorates all the unmourned throughout the world and their families and friends.

KATHARINE HAMNETT / DESIGNER

Gordon Henderson

(USA)

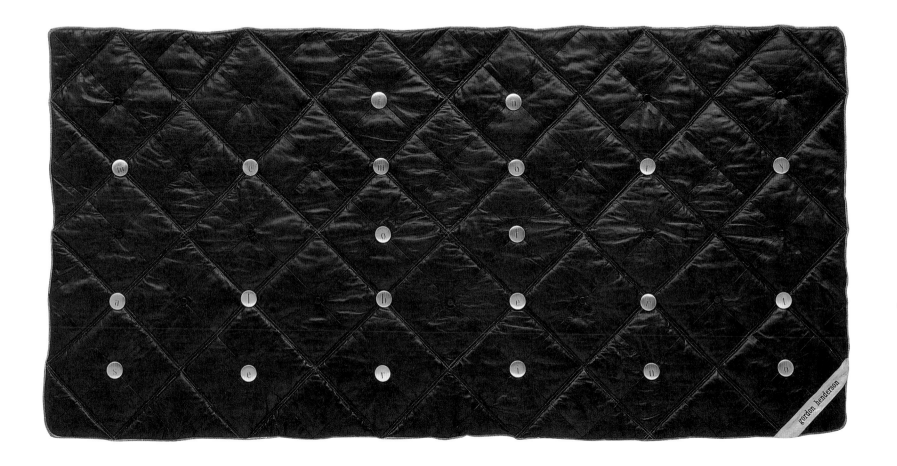

In memory of Albert Serino

Al was a polished marble, gold-plated kind of guy. I distinctly remember him describing the black Mercedes with black leather interior and gold fixtures. That was how I came up with the idea for his panel—to emulate one of the dreams he never had a chance to achieve.

GORDON HENDERSON / DESIGNER

Tommy Hilfiger

(USA)

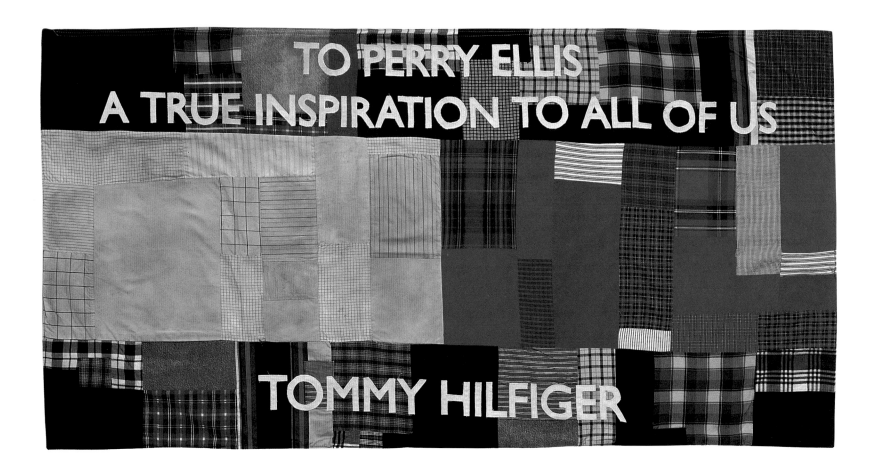

In memory of Perry Ellis

I was inspired by Perry Ellis's spirit. He took American fashion and made it new, injecting humor and his own unique sense of style into each of his designs. I chose the most basic of design techniques for this panel, the rudimentary patchwork that has been part of American tradition since the beginning, yet still translates into American fashion today. The actual design of the panel was not as important as the involvement and kindred spirit it created amongst us. Through this, his memory will live on and be an inspiration to us all.

TOMMY HILFIGER / DESIGNER

Pam Hogg

(UK)

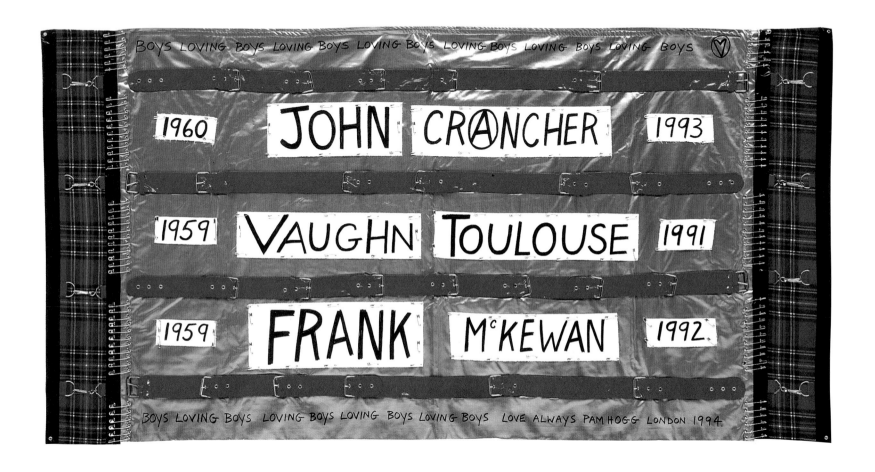

In memory of John Crancher, Vaughn Toulouse, and Frank McKewan

For my friends.

PAM HOGG / DESIGNER

Imaginary Concepts

(USA)

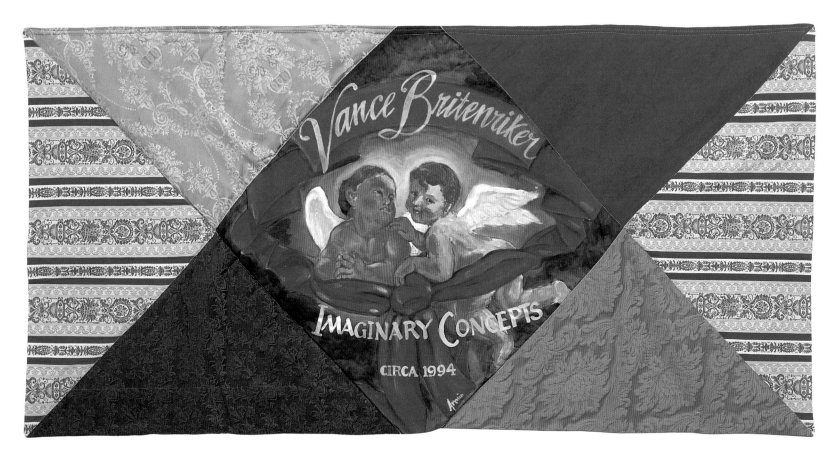

In memory of Vance Britenriker

Vance started off as our neighbor, and then he became one of our very special friends. We shared long talks, summer barbeques, and a passion for art. He was one of the most talented artists we had ever met. He called his art "Nuvo Renaissance."

We were asked to submit a panel design for a fashion event held by Macy's in San Francisco. We knew Vance was very ill and asked him if we could honor him in our quilt design. He was very excited. He loved life, and the only fear he had was dying alone. Two months before we submitted the panel, Vance moved to Ohio to be with his family. He could no longer take care of himself. One week before the panel was displayed, Vance passed away in his father's arms, surrounded by his family.

The panel was designed with heavily textured jacquards and rich colors, all the colors Vance painted and chalked with. We also included two cherubs, which were always in his art and life, one way or another.

Vance was very special, and we were very fortunate to have called him a friend.

MICHAEL AND DORIS LEW / DESIGNERS

Isda & Co.

(USA)

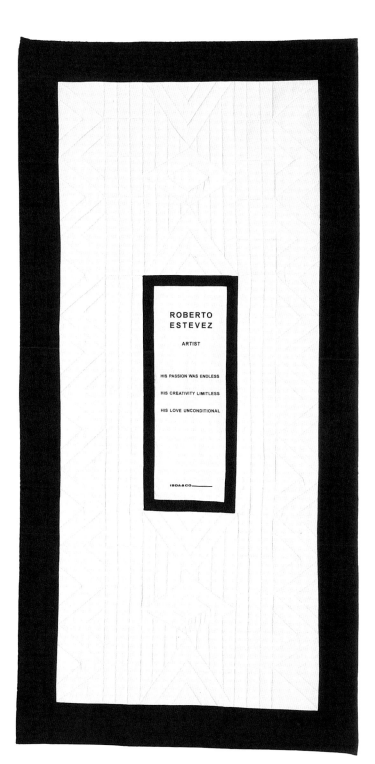

In memory of Roberto Estevez

Many hands and hearts went into making this panel. All of us have been touched by AIDS. We wanted to come together to create a panel to remember the name of someone who is now gone, and by doing this we could help remember all the other victims, too.

After Isda Funari designed the panel, everyone from the company came together to measure the sections, draw quilting lines, and cut fabric. People from all departments—design, marketing, accounting—contributed to the cause. Many swapped computers and calculators for scissors and measuring tapes. Then there were the seasoned pros, who enlightened the rest of us on the finer points of seam allowances and quilting patterns. When our work was complete, we all left the table with a sense of promise.

We did not all know Roberto Estevez, although we all felt we would have been lucky to have known him. Roberto Estevez was one of the early casualties of AIDS. He was a passionate and generous artist. We felt good honoring such a creative man. Creativity is at the heart of our business and in the hearts of so many who have lost their lives to AIDS.

STAFF AT ISDA & CO.

Jeanne-Marc

(USA)

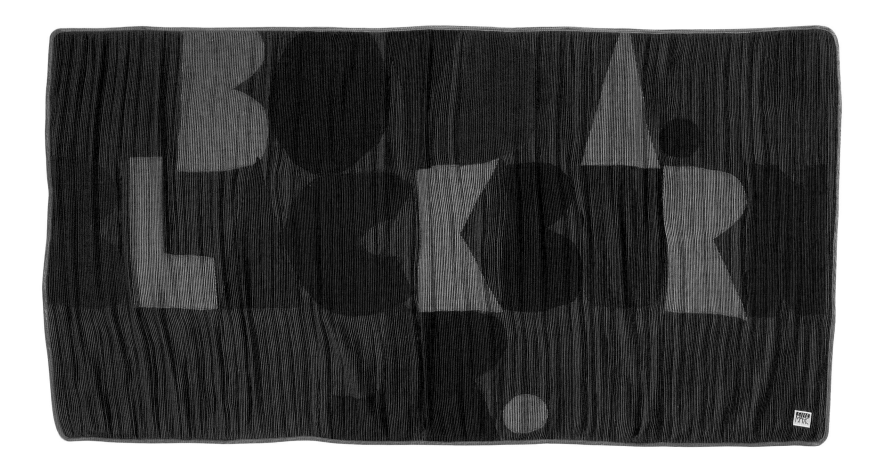

In memory of Boyd A. Blackburn, Jr.

Humor isn't usually the first word that comes to mind when we think of attorneys. But when we think of Boyd, we think first of humor and then of preciseness of mind. Boyd viewed the practice of law as both an art and a science. We appreciated that approach. Boyd was excited by creativity and the art it produced, so we were friends as well as client and counsel. We are lucky that his life path crossed ours.

JEANNE ALLEN / MARC GRANT / DESIGNERS

Jimmy'Z

(USA)

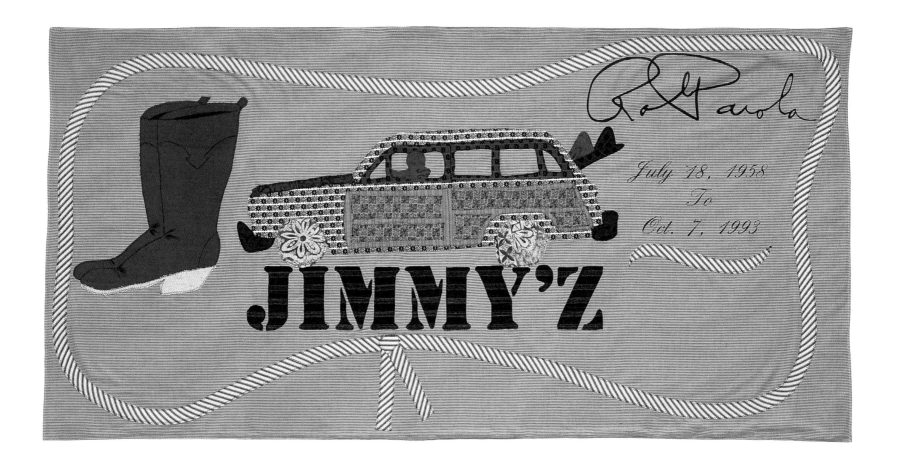

In memory of Rob Parola

In designing the panel, Jimmy'Z wanted to recognize someone in the fashion community who had died of AIDS. Rob Parola was an editor for the *Daily News Reporter* who often worked with our public relations staff. We are sure that he would have been proud to be immortalized in this very special panel. As hard as it is to encompass his life in a single panel, we hope we have done him justice.

AMY Y. OTO

DESIGNER/MERCHANDISER

SIMON BRANSCOMBE

PANELMAKER

KATHLEEN CAREY

PANELMAKER

Jocko, Inc.

(USA)

In memory of Doug Devault

There are some people who come into your life who are so memorable that even when they are gone, they still continue to exert a strong influence. Doug Devault was one of those people.

He was my best friend, my confidant, my hero. He could transform the most trivial of occasions into an event. Remember the story of "Stone Soup," in which no one wanted to contribute to making the soup until someone offered the stone—which became the basis of a delicious broth. Doug was the one with the stone.

As I struggle with his death and the deaths of so many of my friends, I have tried to find a meaning in all of it. The only satisfying way I can look at the epidemic, a point of view that replaces my anger with serenity, is this:

My friends were *saviors*. In death, they opened the eyes of the living around them by demonstrating in a very dramatic way that gay people exist in everyone's lives, in their families, in their workplace. The gravity of their deaths made my and others' struggle with coming out trivial by comparison. Would that some of my friends only had "coming out" as the big issue in their lives now.

I have vowed that all these deaths would not be for nothing, and I do not think they have been. We exist, and we exist in stronger numbers, younger numbers, and with more self-esteem than ever before. I heard recently that the average age of gay males coming out was now sixteen. I was astounded! And, more important, grateful that they don't have to waste the time and energy so many of us did, trying to please a society that didn't understand us.

So, my friend, Doug, you are still my hero, my savior. Your life went for the greater good—for the rest of us, and, yes, even for the unborn of the future. I miss you more than ever.

MICHAEL LEE / DESIGNER

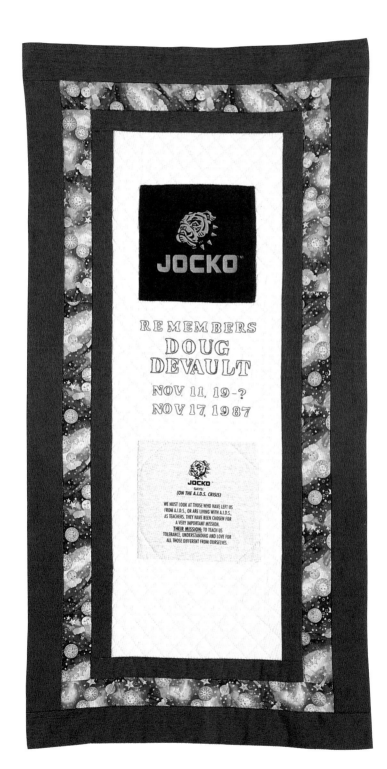

Joe Boxer

In memory of Joey Benko

Joey was eleven when we met.
He possessed the unjaded wisdom of someone much older.
He had the sense of humor of an experienced stand-up comic.
He had one of the quickest wits I have ever seen.
He had the innate ability to know when someone was sincere or not.
He dealt with his condition with dignity and strength.
Joey was twelve when he left us.

The quilt is black and white because of his clarity of thought.
The happy face is something we use all the time at Joe Boxer, and it made him happy.
He always called me Joe.

Joe misses Joey.

NICHOLAS GRAHAM / DESIGNER

Gemma Kahng

(USA)

In the fashion industry, too many talents have been taken away by AIDS. Although I did not have the privilege of knowing any of them personally, their work has inspired and touched me. I would like to dedicate my panel to those designers who are no longer with us but whose influences and contributions are so great, that they will not be forgotten for a long time to come.

GEMMA KAHNG / DESIGNER

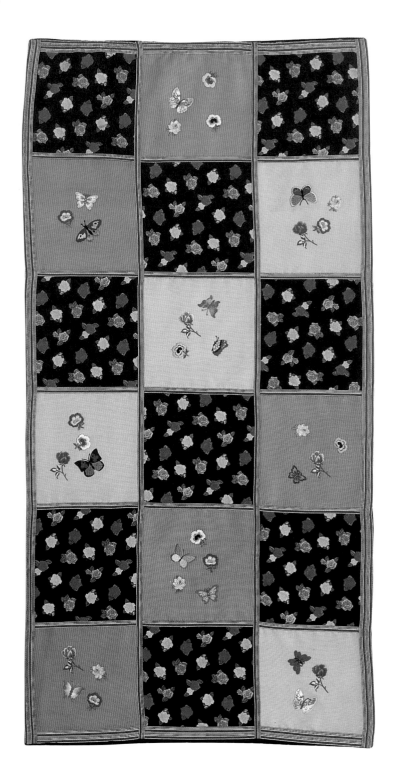

Ninivah Khomo

(UK)

In memory of Margot

I made this panel for Margot Walten-Clark. She was a very good friend of mine and also a devoted client. Margot adored leopard print, so this panel with the animal print is perfect for her. I am sure she would have loved it.

Margot and I did our serious growing up together. We bought our first flats in the same building. We both had children. Sadly, Margot leaves behind a little girl and a little boy.

Margot was a very extroverted person, and when I think of her, I am constantly reminded of her words: "Darling, come 'round for a drink." Upon arriving at her house, I would find many others also popping in for a drink. Margot had the ability of bringing together friends from all parts of the world and from all circles of life, and we are now left with a void that will never be filled.

Her tragic death from AIDS affected me a lot; I have lost many friends to this deadly disease. Working in the fashion industry, hardly a week goes by now without some involvement with the AIDS cause. (As I write this statement, I have just sent some clothes to *Fashion Act,* an English fashion AIDS charity.)

Hopefully soon, we will find a cure. For Margot and all the hundreds of thousands, it is too late.

NINIVAH KHOMO / DESIGNER

Nicholas Knightly

(UK)

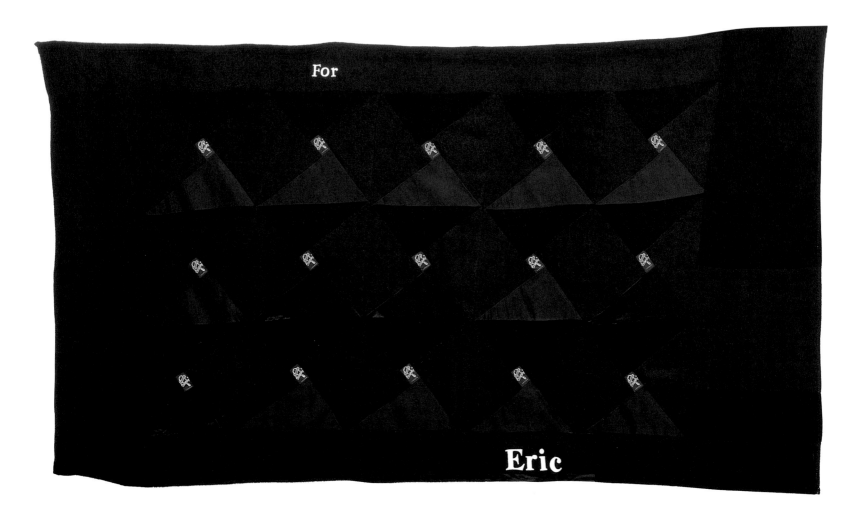

In memory of Eric

Black is the color of mourning, the emotions and the void that exist after the loss of someone close. This disease has taken so many young and talented, who live on in our memories and thoughts.

I remember Eric for his bravery and determination to stamp out ignorance and prejudice. The Quilt is a collective expression that carries a message to help eradicate ignorance and poverty, the only barriers that stand in the way of halting the pandemic.

NICHOLAS KNIGHTLY / DESIGNER

Krizia

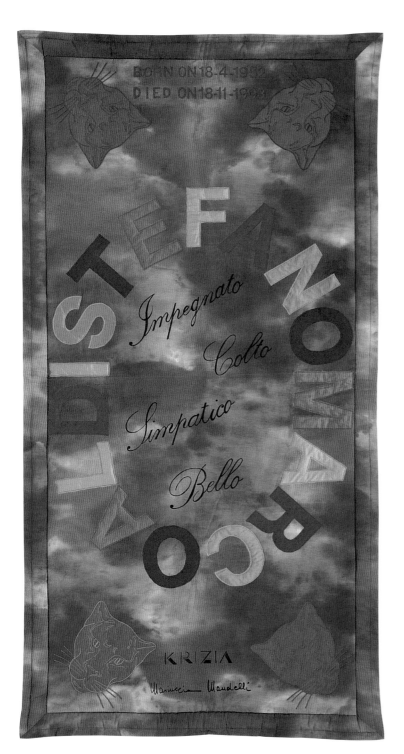

In memory of Stefano Marcoaldi

Our panel is dedicated to a dear friend, Stefano Marcoaldi, who passed away recently: it is in memory of his courageous commitment and his extraordinary talents, which enabled him to face even the most difficult situations and turn them to his advantage. He was a sharp-witted, perceptive, spirited journalist, whose high standards, total dedication, and great strength of mind made a precious contribution to the work of the Italian organization Associazione Solidarietà A.I.D.S., of which he was chairman.

MARIUCCIA MANDELLI / DESIGNER

Christian Lacroix

(France)

In memory of Gilles

Joy, friendship, and success were constant companions of Gilles, like the essential ingredients of any human recipe. We both shared a keen sense of sarcasm, which brought us closer together. Our time was filled with many silences that were full of knowing. Much of his beauty came from his soul. Warm outside, warm inside, with no circumlocution or lies. Fair and gentle eyes that had nothing to hide and everything to give.

His passage in this world was brief. I will never understand why, on a sunny day in May, AIDS grabbed him away. From painting, his family and friends, his town, music, and life.

I remember thinking how I would sell my soul to the devil to keep Gilles from suffering. It didn't work.

How dirty the sky of our lives without the sun to illuminate it. Is he gone? And can we believe in love without the one we used to love?

We all have lost loved ones to AIDS. It doesn't discriminate; by striking at random it finds a way to hit all of us. I want to believe that those who have died are not alone, and I hope that from time to time, they are still looking at us with affection.

Gilles, wherever you are, I hope this will reach you. Here, your bike and brushes are still in the same place. Rock and roll hasn't changed, the Dordogne River flows, and we try to live. You would certainly wish for us to do so. Love will win!

CHRISTIAN LACROIX / DESIGNER

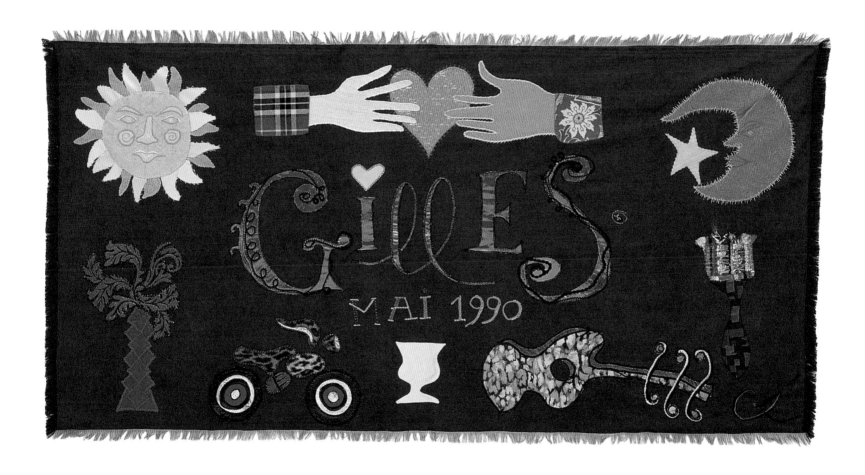

Kenneth Jay Lane

(USA)

In memory of Robert Fraser

So many wonderful, talented friends have been stricken and died of AIDS. What makes this disease so terrible is that there is no hope. Let's pray that this will not always be.

Robert was a great friend and the first person I knew to have AIDS. AIDS was practically unknown then; alas, this is not the case today. Robert loved New York. That is why I have made this panel in his memory.

KENNETH JAY LANE / DESIGNER

Helmut Lang

(Austria)

In memory of Frederic Wright

I made this panel for Frederic Wright, whom I did not know personally, although I know from his brother Eric Wright, who is a dear friend of mine, that he was a wonderful person. I wanted to make this panel to show Eric that I am with him in his deep mourning for his brother.

HELMUT LANG / DESIGNER

FREDERIC WRIGHT † 94

Wendy McCauley

In memory of Geoff Launders and friends

Geoff Launders was my dear friend and personal fitness trainer. I saw him at least three times a week for almost five years. He owned a gym in West Hollywood called One on One, and he was one of the first people in the fitness field to offer personal training. Many of Geoff's employees who were also trainers died of AIDS, too. When Geoff found out he was HIV positive, he continued working. He maintained his positive attitude and his great sense of humor, even joking at times about the disease.

Geoff spent the last two weeks of his life at Century City Hospital. My friend Thom and I visited him almost every evening in those final days. On our last visit he told us, "I don't feel that bad. I don't think I am going to die."

Well, he did die. In his last hour he told his friend Michael at his bedside to tell Thom and me what good friends we had been. It was heartbreaking to see him go. I decided to tell his encouraging story through the AIDS Memorial Quilt.

I miss Geoff very much.

WILLIAM ESCALERA / CO-PANELMAKER

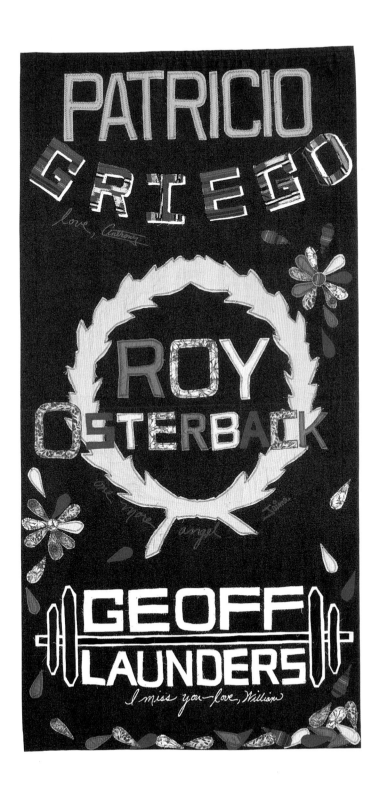

Mary McFadden

(USA)

In memory of Wray Gillan

If ever I enjoyed the company of anyone,
it was the company of my friend.
But now he has gone.
Though Rab'eh was a match for a hundred
spiritual warriors
he could not vie with that good man,
my friend.
The ache in my soul will not let me describe
the grief that I now feel.
He was no mere man, my friend,
but a spiritual man!
Mighty indeed were his night-long prayers,
and wonderful his midnight sighs, each
opening a way to God.
Detached from the world, he chose seclusion
from mankind,
a private corner, away from all creatures,
He turned his face to Thee, O guide,
knocking often on Thy door.
So open it

After Attar's *Khosrow Nameh*

MARY MCFADDEN / DESIGNER

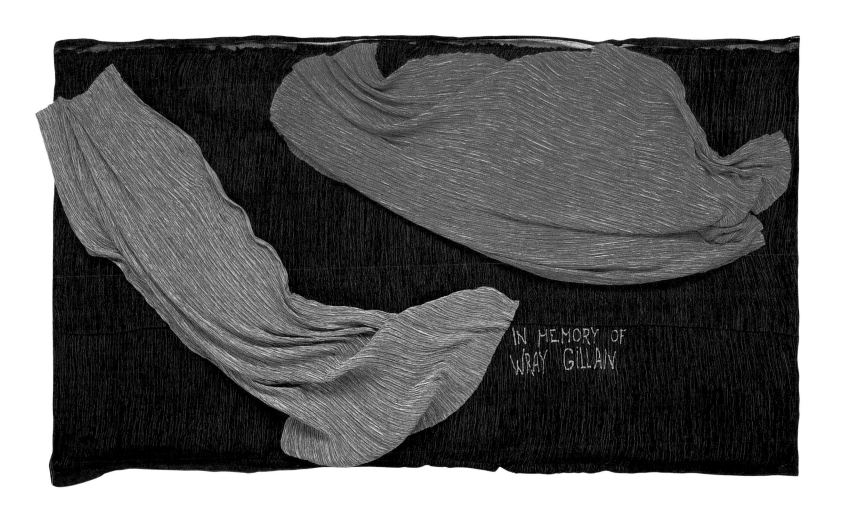

Martin Margiela

(France)

In memory of those who have died of AIDS

We wanted to list the names of all our lost friends, but unfortunately, there were too many.

THE TEAM AT MARTIN MARGIELA

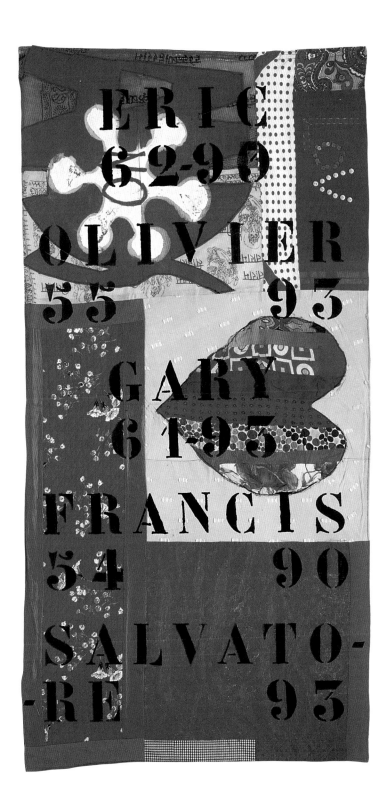

Isaac Mizrahi

(USA)

In memory of those who have died of AIDS

The star as a symbol has such significance for me on so many levels. The star's radiating design stands for merit and special ability, and in astrological terms the star has always been linked to one's personal destiny. I chose to represent these ideas in my panel, to highlight the talent, wit, and vitality that have been extinguished by AIDS.

ISAAC MIZRAHI / DESIGNER

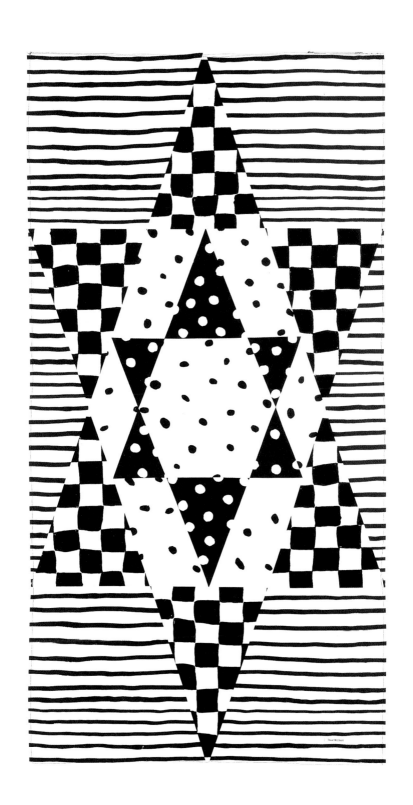

Thierry Mugler

(France)

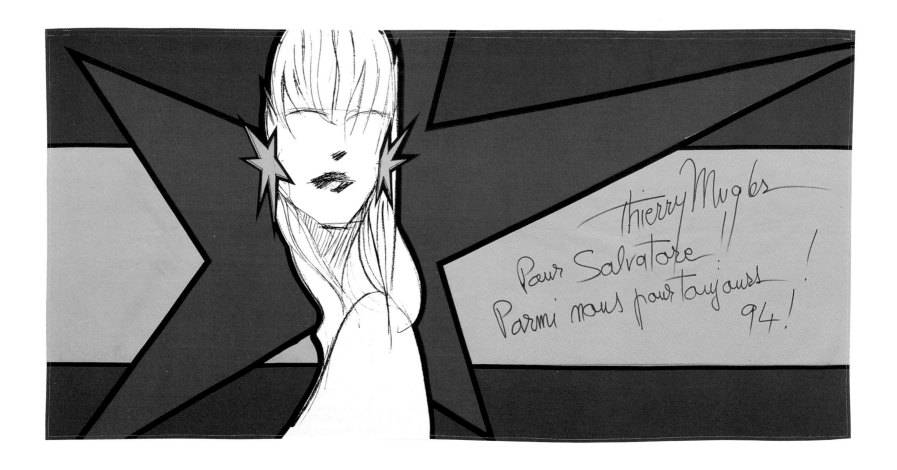

In memory of Salvatore

Salvatore was a very talented artist and poet. And poets are eternal.

THIERRY MUGLER / DESIGNER

Natalie D.

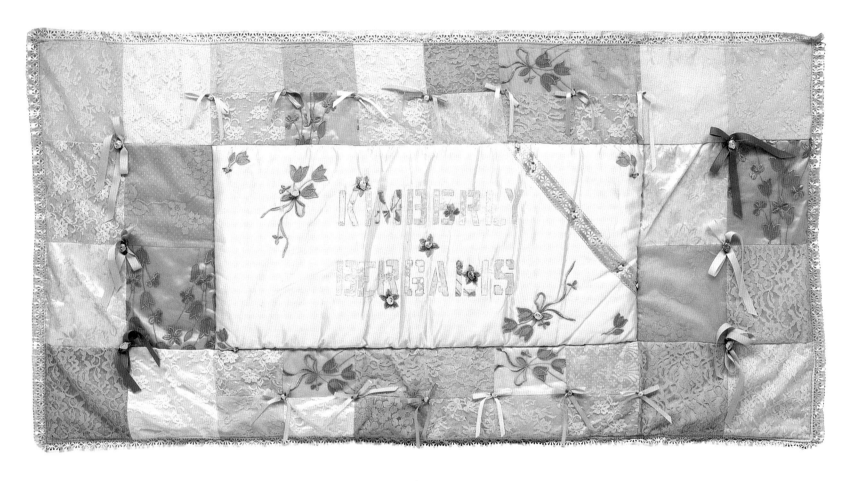

In memory of Kimberly Bergalis

I dedicated the panel to Kimberly Bergalis because of the lack of attention to women afflicted by AIDS. As I researched this horrible disease, I found there to be thousands of women and children suffering from it. I was inspired by Kimberly's strength; in such a fragile state, she went to Washington, D.C., and addressed Congress, asking for help and more awareness for this God-awful epidemic.

In the time since I made the panel, the world has also lost Elizabeth Glaser, a woman on the forefront of pediatric AIDS awareness.

We at Natalie D. wish eternal peace to the victims and inspiration to the survivors, as demonstrated by the strength and courage of these women.

NATALIE DE GROOT / DESIGNER

Terence Nolder

(UK)

In memory of David Clay

King of the Catwalk. Couture Quilt.
Black and White stripe background
with Schiaparelli Pink signatures
of long time friends.
David beaming, as usual, with Turkish
Delight waistcoat.
Keep the Angels smiling in Heaven.
Our loss is their gain.

David was a mate. A soul mate. I sometimes wouldn't see him for months on end, and then the bell would ring at my studio, and there he'd be, beaming. Chesire cats could not compete with David. He'd stay a while, catch up on all the gossip, and then after raiding my fabric stockroom, go happily on his way with another selection of brocade offcuts with which to enlarge his collection of waistcoats.

David liked waistcoats, which is why I appliqued one onto his panel. Sadly, he never saw this design, but I know he would have loved it.

People like David always leave a big hole in your life because he was always there. He used to say, "Once you've tasted black you'll never look back. The darker the meat, the sweeter the treat." Well, treats didn't come any sweeter than David. I needed to make this panel because David died while I was away on a business trip, and by the time I returned it was too late for me to get to Holland for the funeral. I felt so sad not to be there. This panel is my way of saying I cared, and I will always remember him. You always feel cheated when you lose somebody so young, but AIDS has no conscience. David cannot be replaced. David was unique. He will be remembered long after AIDS is history.

TERENCE NOLDER / DESIGNER

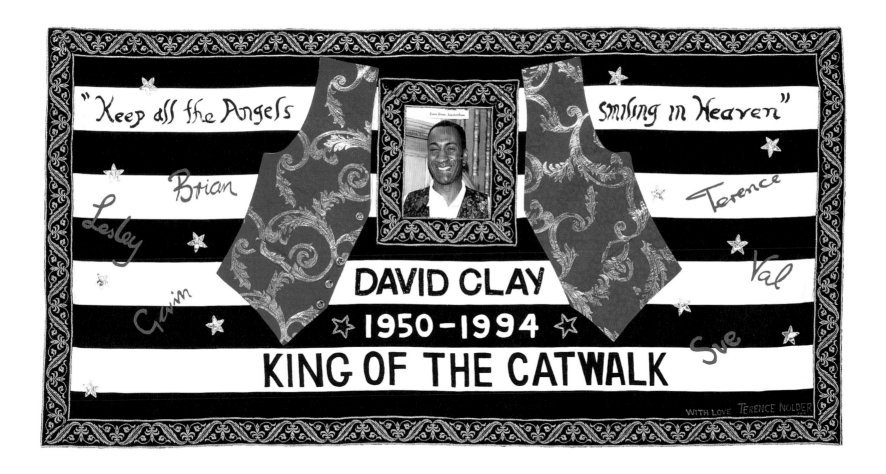

Todd Oldham

(USA)

In memory of Perry Lee Bentley

It had never occurred to me prior to meeting Perry that some people are just simply not like anyone else. Everything he said, saw, touched, and did seemed special! To describe Perry's tastes would require a new word; *sublime* is not descriptive enough. To be invited to his home was at once an honor and a thrill. Cy Twombly paintings next to carved Mexican cantaloupe napkin holders. His generosity was large. No matter where Perry's travels took him, you felt a part of his journeys. He was the perfect postcard pal.

What I learned most from Perry is a feature I try to celebrate daily, the importance of being singular. I miss him.

TODD OLDHAM / DESIGNER

One by Two

In memory of Yann, William, and Mitchell

Yann: Comrade • William: Flamboyant • Mitchell: Joker

Three friends who passed through my life ever so briefly. Our times together of laughter, sharing, and more laughter are still alive in me. Three strong souls that shared their passion for life with me.

AL ABAYAN / DESIGNER

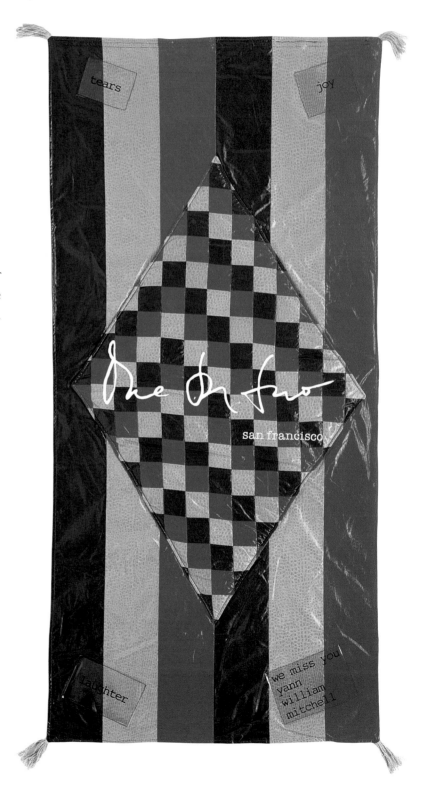

Flyte Ostell

(UK)

In memory of friends

Our panel is white and simple. It is for our friends Anthony, Christian, Kevin, Richard, and all the people who are living with and have died from AIDS.

ELLIS FLYTE / RICHARD OSTELL / DESIGNERS

Rifat Ozbek

(UK)

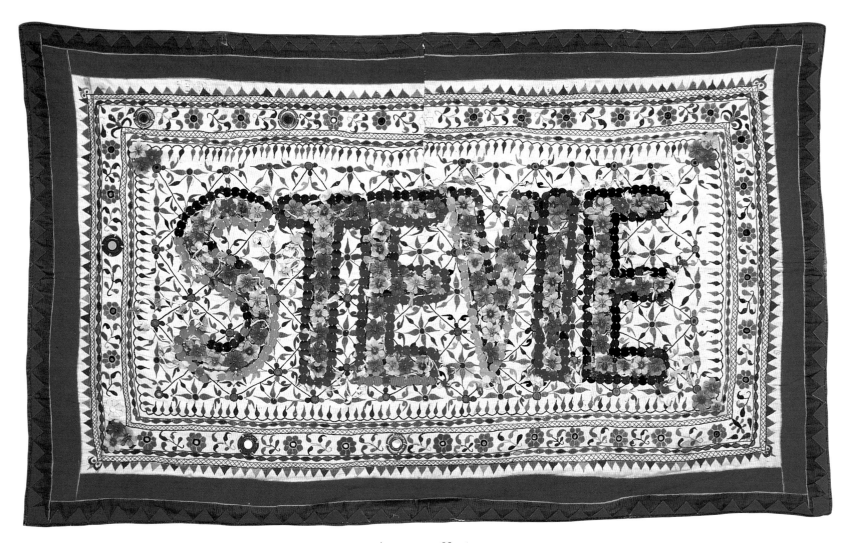

In memory of Stevie

My darling Stevie,

Miss you lots Mum, your performances, your humor, your wit, your jokes, your laughter. Every time I see a guy over six foot, I think of you. I'm sure you're having a fantastic time in disco heaven like you did on disco planet.

Love you forever,

A.K.A. Chipy

RIFAT OZBEK / DESIGNER

Polo/Ralph Lauren

(USA)

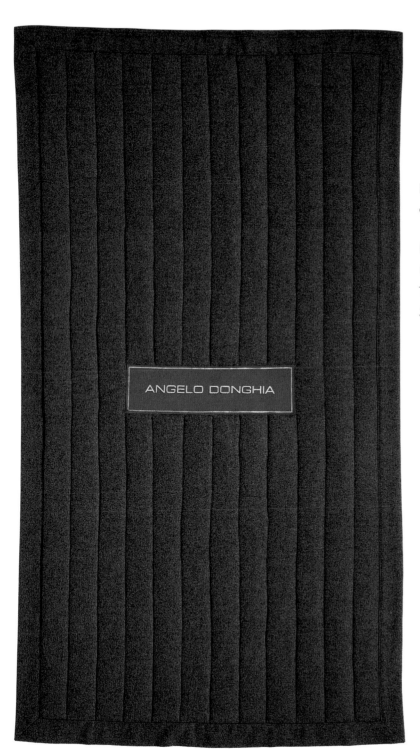

In memory of Angelo Donghia

My memories of Angelo Donghia's great personal style and modern elegance inspired the design for this panel.

I had the great pleasure of knowing Angelo and worked with him on our family home in Jamaica as well as our New York apartment. He was immensely talented and made a significant contribution to the design world. He is still recognized as one of the most gifted designers, and his untimely death is a loss to us all.

RALPH LAUREN / DESIGNER

Antony Price

(UK)

In memory of Paul and Nelson

My closest losses were Paul and Nelson. Paul Chandler was a gorgeous white Bajan boy, suntanned with blue eyes. I knew him for about ten of the twenty years I spent visiting Barbados. He was a mad dancing island boy who went on to college in New York. Paul died about five years ago. My memories of him are preserved thanks to a wonderful self-portrait he gave me.

Nelson Davey was a boy from Christchurch, New Zealand, who came to England and joined me as my assistant in 1982. He worked for me at a time when I produced two particularly magnificent collections that were shown to paying audiences in enormous discotheques. He was extremely clever and dedicated and had a brilliant, dry sense of humor.

When I thought of these two boys and recalled memories of the Caribbean, the ideas fused with my 1950s eccentrically English idea of God and led to a house-style, homeboy Byzantine prayer look.

ANTONY PRICE / DESIGNER

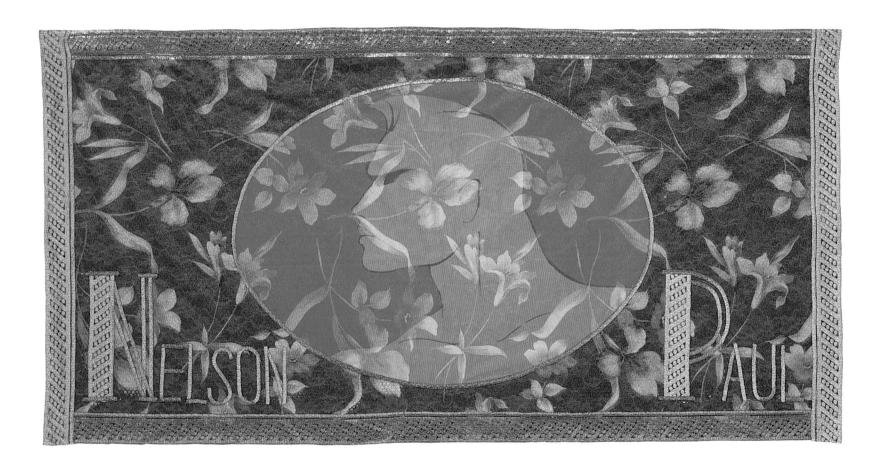

Claudia Rey

(UK)

In memory of those who have died of AIDS

Don't tell me about nowhere to go . . .
Don't tell me about nothing to do . . .
Don't tell me what they can . . .
Don't tell me that you can't . . .
Don't tell me, I won't listen . . . it's only lies.

But maybe you will tell them
And maybe "no choice" will be all they have
 Maybe they will listen . . .
And maybe they will cry.

This panel, Help for Love, is directed to all multinational companies and governments around the world and is dedicated to everyone I know and everyone I don't know who has this virus. In my country we have an expression: "Hope is the last one to die." So let's keep hoping.

CLAUDIA REY / DESIGNER

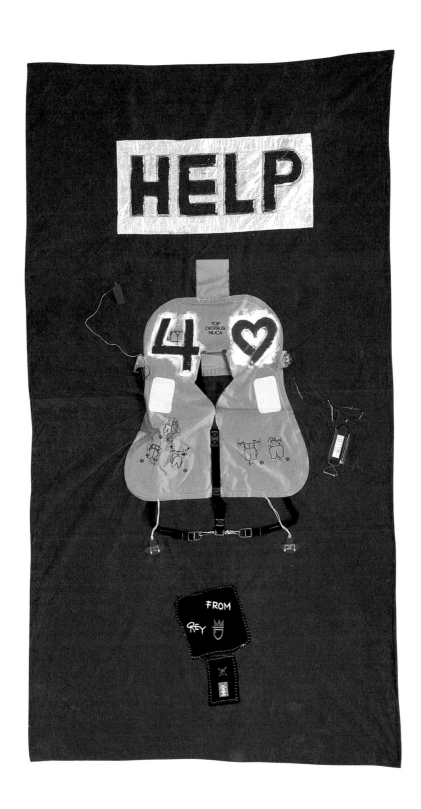

Rialto, Inc.

(USA)

In memory of David Jenkins

Making the panel for David was a time for reflection, a time to merge the past with the present and to think about the AIDS epidemic. AIDS has had a devastating effect on the art world and the fashion industry and, most important, on our lives, which have been so altered by this disease.

We searched for the right meanings: a special tribute to a friend who was a man of vision and conviction. David Jenkins loved what was new and exciting. He applauded the unique and the creative. He was a master craftsman and translated advanced concepts into marketable ideas. He shared his knowledge freely, giving advice and direction to many of us.

The souls in repetition represent how our lives are all intertwined, yours touching mine and, in turn, mine blending with another's. The colors of the silhouettes represent individuality and reflect the transformations in our journey through life.

David, you left an impression. The world was changed by your presence, and today you are missed. Until we meet again.

SHARON KEASLING / JOY PERRERAS
DESIGNERS

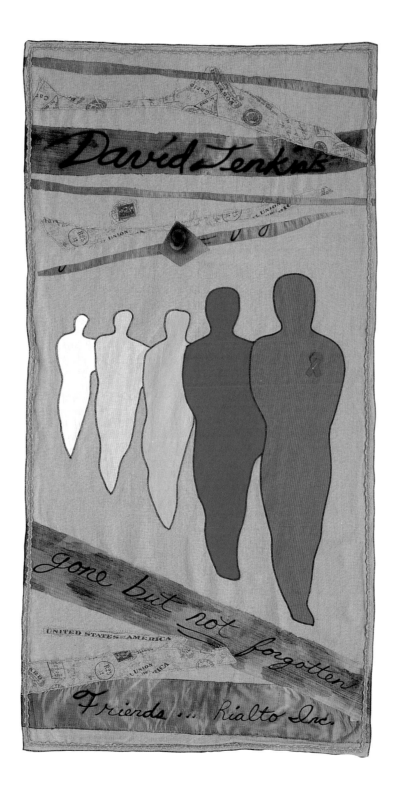

Roberto Robledo

(USA)

In memory of Roberto Robledo

As I watched you fade,
I knew that you had passed into the light
and I to the bottom of the darkest hole.

There I stayed
not thinking
not feeling.

My pain
drove me to my bed.
My work
became the reason I rose.

Even in darkness, we have memories.
The blind can SEE.

I recalled the times before.
We always said we would spend a lifetime together.
And we did.
I never guessed it would be yours.

For twenty-two years
we shared every emotion to its rawest extreme.
Anger was hate.

Love was passion.
But mostly we laughed and enjoyed the same crazy sense of
 humor.
We had respect for each other.

I remember the day I accepted my loss
and sat peacefully observing the beauty in which we live.
I heard you say,
"Oh Larry, there is more than this!"

At that
my world brightened
and became clear.

I once again feel joy and have goals.
I am happy to live my life for me.

And often I pause and smile
as a thought of you blows through me.

My friend
my lover
my brother
my son.

LARRY TAYLOR / DESIGNER

FRIEND LOVER BROTHER SON

ROBERTO ROBERTO

1953 — 1993

LOVE HEALS

John Rocha

In memory of those Irish who have died of AIDS

This panel commemorates the thousands of people who have died from AIDS in Ireland. Everyone in this small country is being affected, directly or indirectly, by the threat of the disease.

As a nation, we have always had a very strong sense of family and community. We pride ourselves on our history and our traditions of craft and culture. This panel aims to represent these elements, combining time-honored skills and the safety and warmth of home. It honors the dead and dying together with those who continue on, to support and comfort.

I would especially like to thank the Dublin AIDS Alliance for their help and advice.

JOHN ROCHA / DESIGNER

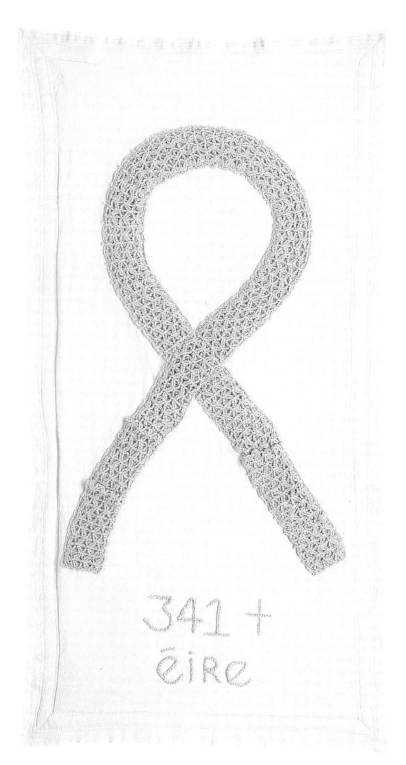

Sonia Rykiel

(France)

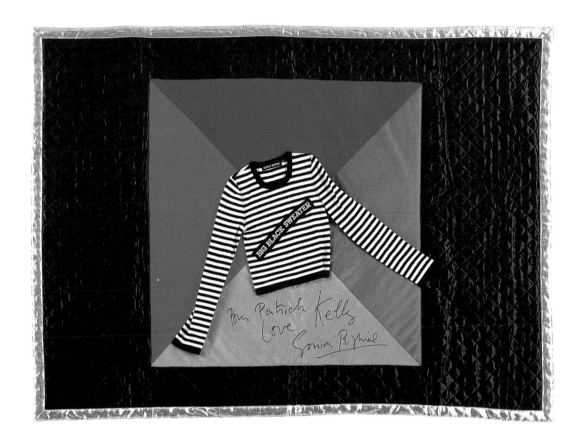

In memory of Patrick Kelly

Tous les morceaux du patchwork ensemble pour protéger.
Tous les morceaux du patchwork ensemble pour la recherche.
Tous les morceaux du patchwork ensemble pour aider.

All the quilts together to protect.
All the quilts together for research.
All the quilts together to help.

SONIA RYKIEL / DESIGNER

Yves Saint Laurent

(France)

In memory of Stephen

We are ravaged by AIDS. People with HIV must take heart and not lay back and die. There must be no respite in the battle to defeat AIDS.

YVES SAINT LAURENT / DESIGNER

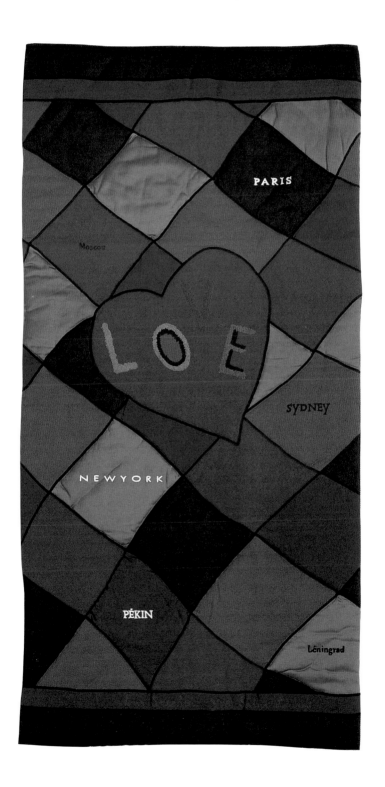

Martine Sitbon

(France)

In memory of Patrick

Patrick was a truly great artist and special friend. AIDS has affected a great number of artists. This is such a tragic loss to all of us, as they lead the way in creativity and direction in life.

The lamé panel reflects Patrick's sensitive nature. The design projects an abstract, spiritual quality with an insight into a new life. There is an emphasis on the choice of subtle, hand-dyed colors and stitchwork, with a minimalistic approach.

Patrick is dearly missed.

MARTINE SITBON / DESIGNER

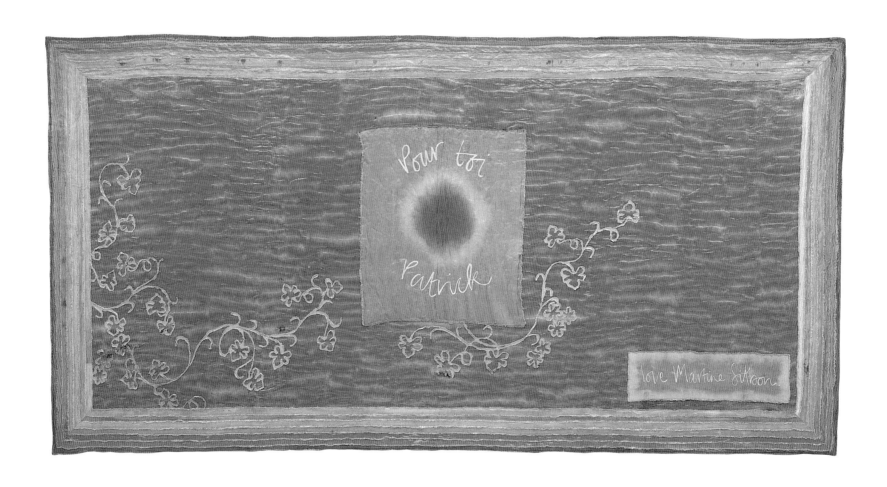

Paul Smith Limited

(UK)

In memory of Richard Kyle Waterman

This panel was made in memory of a young man who worked for us in our New York store, hence the Stars and Stripes and the Union Jack. AIDS has been very much part of my life as it has affected so many in the world of fashion, photography, and the arts.

PAUL SMITH / DESIGNER

How do you remember someone best? Is it for contributions they made to your life, or for moments you just can't forget, or is it the void they leave when they're no longer around? Richard definitely touched everyone who knew and loved him in all these ways and more.

When I think of Richard, the one word that always comes to mind is gentleman. He was the epitome of the actual words, *a gentle man.* Carrying himself elegantly through each day, always groomed immaculately, he was indeed "Mr. Richard," as one of his clients affectionately addressed him.

He always had a certain calmness about him and would instill this in others. Even when everyone around him would be losing it, he'd put on a show. More than likely it would be a Tina Turner number. "What's Love Got to Do with It?" always seemed appropriate. At the same time, Richard was the only person I knew who could work hard all day and still manage not to wrinkle his linen suit.

Every now and again I can hear Richard saying "puh*leease*" or "*garrosse,*" and it helps to lighten up the day. His generosity and unselfishness taught us all to go through life with just a little more class. After all, as he would say, "It's not the end of the world, it's just fashion."

STEVE MCMAHAN / DESIGNER

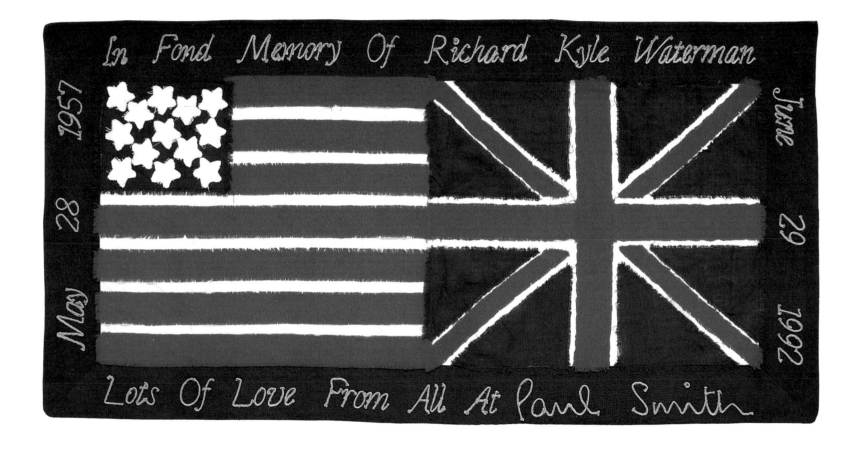

For Willi Smith

(USA)

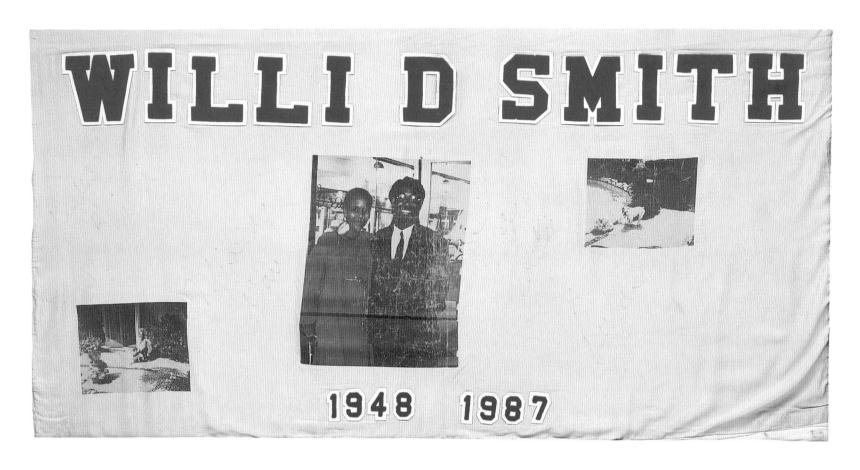

In memory of Willi Smith

Willi D. Smith was my brother, growing buddy, friend, teacher, and spiritual partner. We shared so many moments together through the years. We saw each other through many phases of our lives, good and bad. I wanted the best for Willi. He wanted the best for me. We wanted the best for each other.

We had early common dreams. We loved fashion, fantasy, and dreams and experienced many. We had an incredible curiosity for learning and giving. The last seven hours I spent with Willi in the hospital before he went into a coma, we talked of our early memories up to the last moment.

I love you, Willi, and know our sister, mommie, daddy, and all our friends are happy where you are, looking down and protecting. Rufas and I love you.

TOUKIE SMITH / SISTER

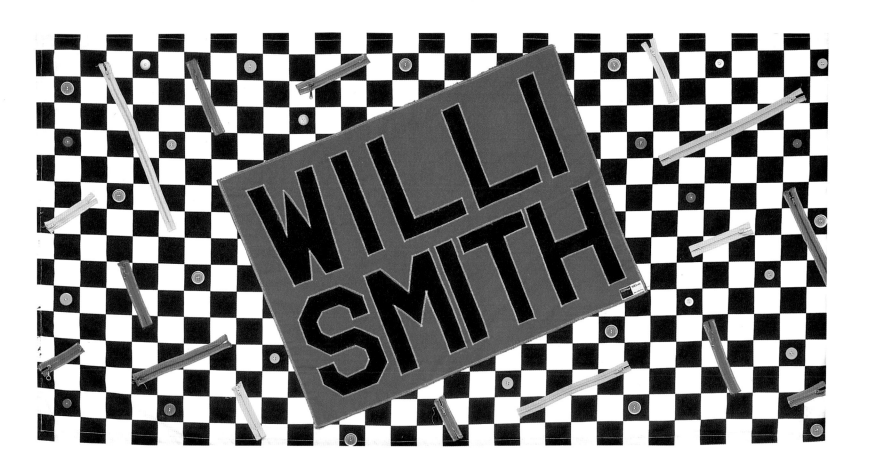

In memory of Willi Smith

I made this for Willi Smith not only because he was a celebrity but because he had a real effect on my life. In making the panel, I thought about all his colors and designs. He was a very colorful person, so it had to be pure graphic colors.

ROD SHELNUTT

Spaghetti

(UK)

FOR
TINA

*Love
Nadia*

*forever yours
Manolo*

In memory of Tina Chow

This panel for our friend Tina Chow was made in memory of her flawless
elegance in life and her courageous dignity in death.

MANOLO BLAHNIK / NADIA LA VALLE / DESIGNERS

Lawrence Steele

(Italy)

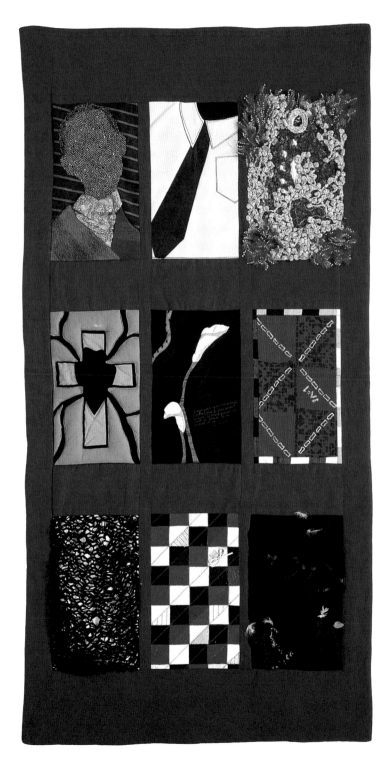

In memory of Scott Barrie

I knew Scott Barrie as a student. He was one of the few black American designers on Seventh Avenue, and his work at the time was an inspiration to me. I later met him in Milan, where we frequented the same people and places and over the years became friends.

I heard about Scott's death sometime after his funeral. Very few people knew Scott was sick. I had no idea. A mutual friend informed me of his passing. The NAMES Project has enabled me to share my respects with others who knew and loved Scott.

LAWRENCE STEELE / DESIGNER

Because death should not have the right to mark any human being with such cruelty.
Because I am tired of erasing so many loved ones from life in this way.
Because I want to continue to love without feeling sorrow.

GIORGIO CARTA / PANEL COLLABORATOR

Helen Storey

Quilt for an unknown child

From somewhere deep inside an unfairness unjustifiable rages,

A rage for the painful passivity displayed on the faces of children for whom life is defined by disease,

An agony enough for those who have experienced existence before "it"—
A seemingly godless earth to allow a being unable to shape its own destiny,

this experience of life.

HELEN STOREY / DESIGNER

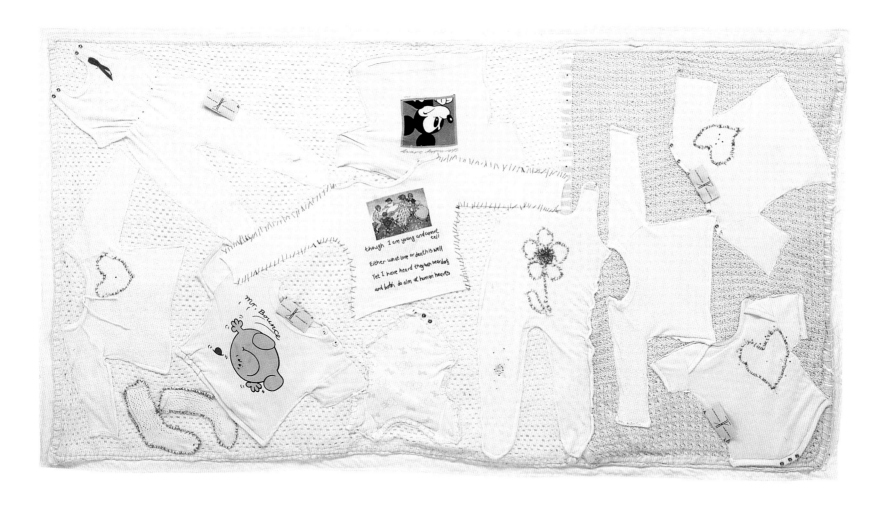

Anna Sui

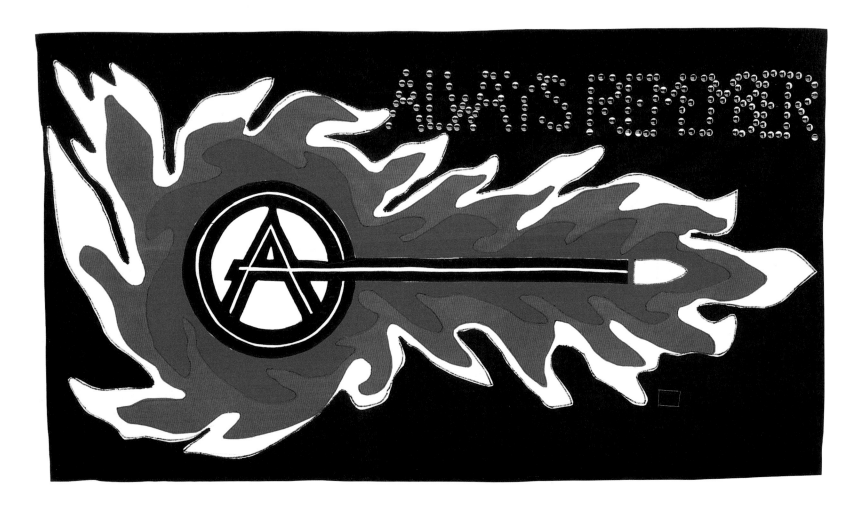

In memory of those who have died of AIDS

The panel I created isn't assigned to one person in particular.
It is dedicated to the memory of all those friends and
colleagues who have passed away.

ANNA SUI / DESIGNER

Celia Tejada

(USA)

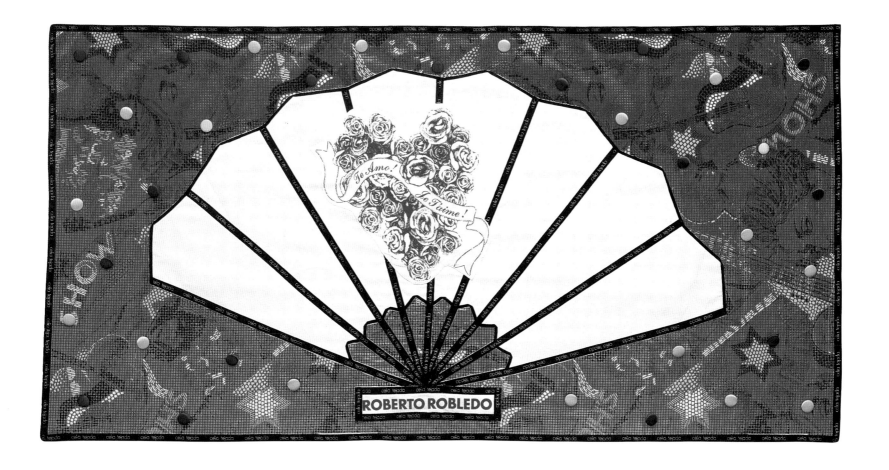

In memory of Roberto Robledo

Roberto was my friend and mentor when I began in the design business. I enjoyed his friendship, sharing the last years of his life. AIDS became a reality through him, a cruel reality that made us all very humble, angry, sad.

It was through Roberto that I saw peace in the last days of his life. I remember Roberto happy, full of life like a Spanish fan full of colors, always with love.

CELIA TEJADA / DESIGNER

Think Tank Design

(USA)

In memory of Michael Hossner

Michael taught me to paint. This is the first painting I made in his studio—it just came out. And though he muttered something about "no accounting for luck," he was proud.

LAT NAYLOR / DESIGNER

Gnyuki Torimaru

(UK)

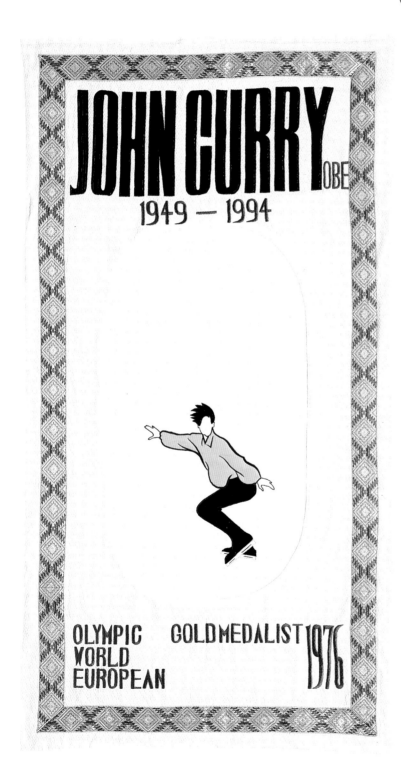

In memory of John Curry

I entertained the idea of making a panel for several friends who were special to me and who had succumbed to AIDS: Tina Chow, Tommy Nutter, Guy Munthe, and many others who are no longer with us. John Curry was the latest on that list.

I met him only once when he came to dinner at my home shortly after he won the Olympic Gold Medal. Among the guests was Natalia Makarova, one of the greatest ballerinas who had defected from the Kirov Ballet Company. John was very interested in bringing ballet on ice to the theater and had much to discuss with Natalia. I remember how his eyes sparkled when he talked so passionately about his ideas.

John was a very kind and gentle person with great strength behind his charming demeanor. He was a unique individual; nothing seemed to discourage him. He took everything in his stride and never lost sight of his goals. He had tremendous influence on the international skating scene, offering a unique style that catapulted British skating to great heights.

John fought hard to achieve his dream. And to his last day he fought hard in his battle with AIDS. This panel is created to celebrate his triumph in life and to pay tribute to his courage, determination, and above all, to his originality and artistry.

I pray for his soul to rest in peace and that his spirit will inspire future generations to create something beautiful and everlasting.

YUKI (GNYUKI TORIMARU) / DESIGNER

Philip Treacy

(UK)

In memory of those who have died of AIDS

My panel symbolizes the delicacy of love and life. Everybody has been touched by the tragic and unnecessary passing of a life that loved.

PHILIP TREACY / DESIGNER

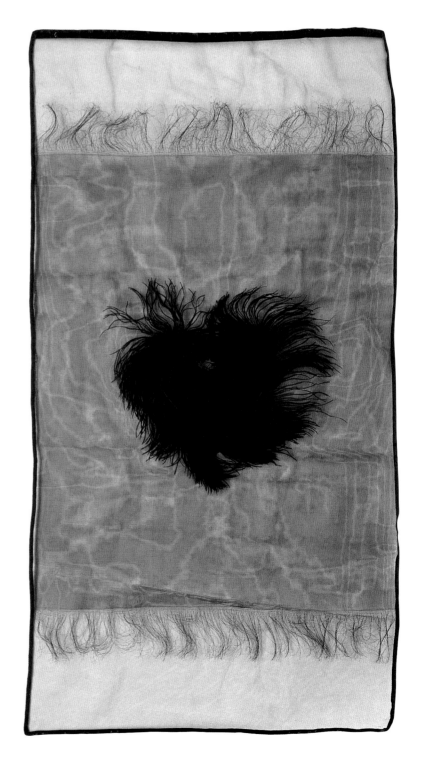

Richard Tyler

(USA)

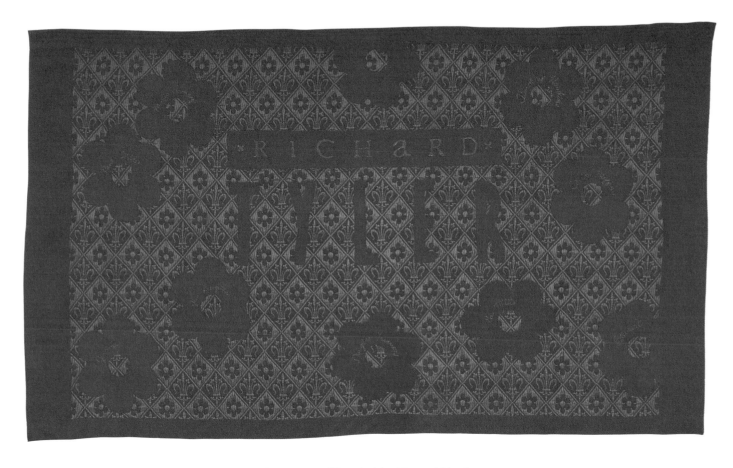

In memory of Timothy Hawkins and friends

It was Timothy Hawkins's vision that gave the first spark to the launch of my design business. When I was pounding the pavement with a bag of men's samples in 1987, totally unknown, he not only put my new men's clothes on the cover of the *Daily News Reporter* twice, but he was the first person to actually buy my tailored "zip-ski jacket" at the IF Boutique in Soho. The confidence that it gave me to have Timothy, who was so deeply respected in the fashion industry, give his appreciative support, was immeasurable. He was always there as well when my wife, Lisa, and I called for advice.

Though our interaction with Timothy only scratched the surface of his warm and generous nature, we often run into friends of his who have helped us get to know the other aspects of the complex, deep, and much-loved man who had graced us all in so many ways.

RICHARD TYLER / DESIGNER

Ungaro

(France)

Homage to Dennis Thim

Death is the dazzling mourning of innocence, blind admission of powerlessness, when it is confronted by infectious laughter, this joy of being, existing and creating, day by day, without deceit, his own existence.

Dennis was life, bold, quicksilver, this fair-hairedness which is the sign of the seducers of the North and one could hear the sound of sea in his eyes.

Death and the sea have taken him back; he is buried in an eternity of which one knows nothing, but his laugh reaches us, tender and attentive witness of this passage of which remains the illusion of perfect happiness, boundless, the deafening silence of his absence.

How to say to him that we miss him, forever, in the shadowy secret of this poetry that binds certain human beings in the silence of words and in the music of a glance.

EMANUEL UNGARO / DESIGNER

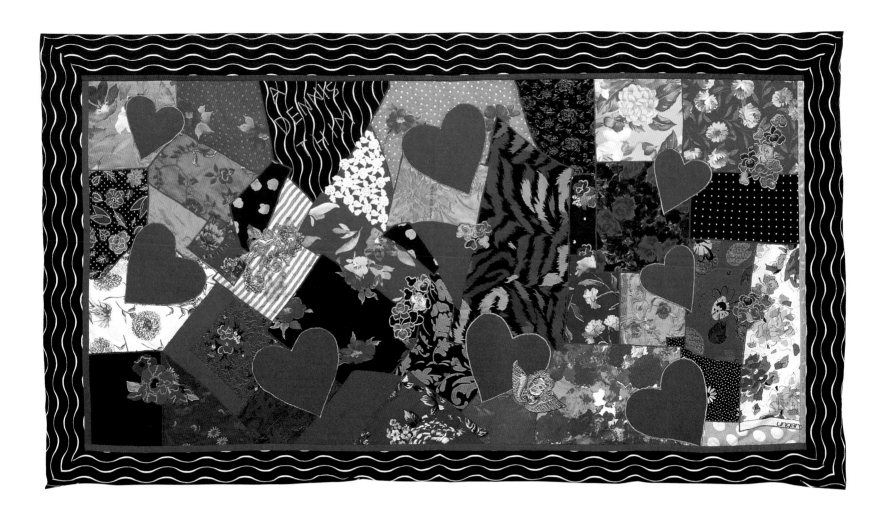

United Colors of Benetton

(Italy)

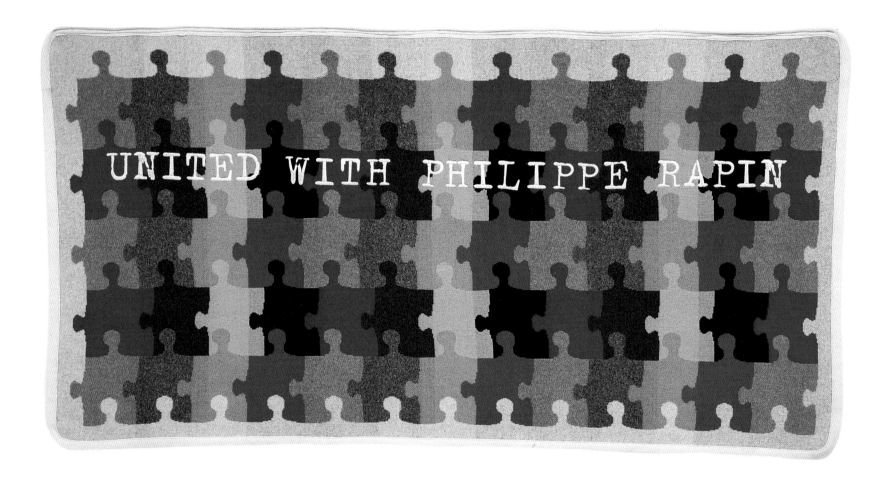

In memory of Philippe Rapin

The love that we have for Philippe is still intact. Inequality, injustice, and racism in all its forms disgusted him. Philippe was energetic, passionate, and generous. Even though we feel immense pain by his loss, our memory of him will forever be a hymn to love.

GEORGES-PIERRE GAMAIN / DESIGNER

Valentino

(Italy)

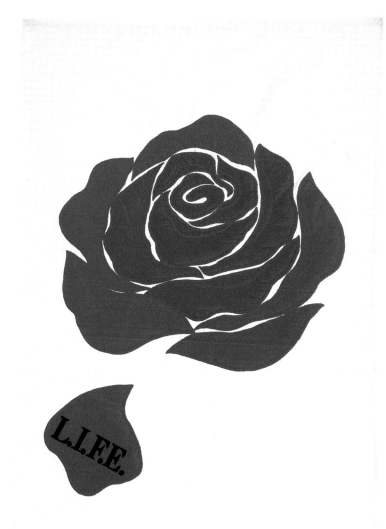

L.I.F.E.

Valentino '94

DEDICATED TO ALL THE CHILDREN WE HAVE LOST

In memory of all the children we have lost

Writing about children with AIDS is not easy. I prefer to work and pray for them.

VALENTINO / DESIGNER

Gianni Versace

(Italy)

In memory of Jorge and Terry

This panel is dedicated to friendship and friends, friends who last longer than lovers, friends of all seasons of life, friends from the past, when you were a child, quarreling most of the time, fighting, arguing and shouting but always looking out for each other, sharing small things, enjoying every minute of each other's company, teenage friends, when life was difficult and complicated, when grown-ups just wouldn't understand, when the world seemed hostile and cruel, friends of yesterday, precious friends who are no longer with you, friends whose presence you miss now because it's now that you need them, friends whose qualities and talent and love for life seemed to have escaped you when they were around but come to mind only now, friends who won't come back, friends who are there to stay and understand, friends you can look right into the eyes without pretending, friends who come and go but will always be there in case of need, friends who listen but don't judge, friends who don't ask questions, friends whose silence means more than any word, friends, just friends.

GIANNI VERSACE / DESIGNER

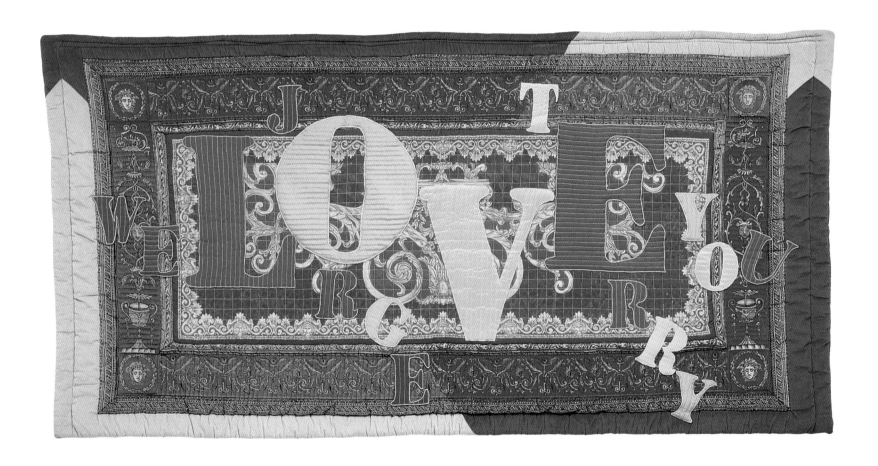

Weston Wear

(USA)

In memory of Spike Lind

Spike Lind was a dear brother and confidant to Susan Chastain and a dear friend to Julienne Weston. He lived his life to his fiftieth year with great exuberance. He was an artist in the style of Leonardo, a man of multiple talents and wide-ranging interests, with a keen eye and a sharp wit.

Art was his calling and vocation. His gifted hand worked in many forms, including portraits, murals, and interior decorative painting. He was a cartographer for two years with the US Army in Japan, then became Art Director at the Charles Eames Studio in Los Angeles for six years before setting off for London to become Queen. His sister's fondest memory of him was when he agreed to come to her second-grade class in his Army uniform for show-and-tell.

Spike always saw the bright things in life. He lived far longer and with greater relish than anyone could have expected. He will be missed by all.

SUSAN CHASTAIN / SISTER

JULIENNE WESTON / DESIGNER

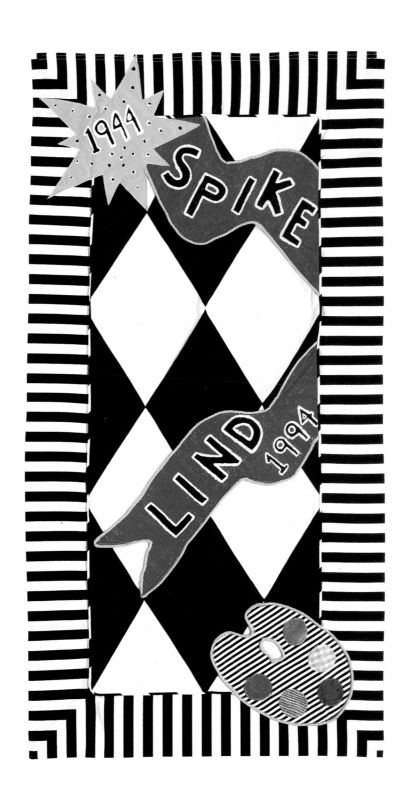

Vivienne Westwood

(UK)

In memory of those who have died of AIDS

This panel is dedicated to all the unforgiven persons who passed away because of this terrible disease. My quilt is for all of them, but I particularly thought of Bill Gibb, a talented fashion designer in Chelsea who was well known in the late seventies. We belonged to the same community, and I admired his work tremendously.

VIVIENNE WESTWOOD / DESIGNER

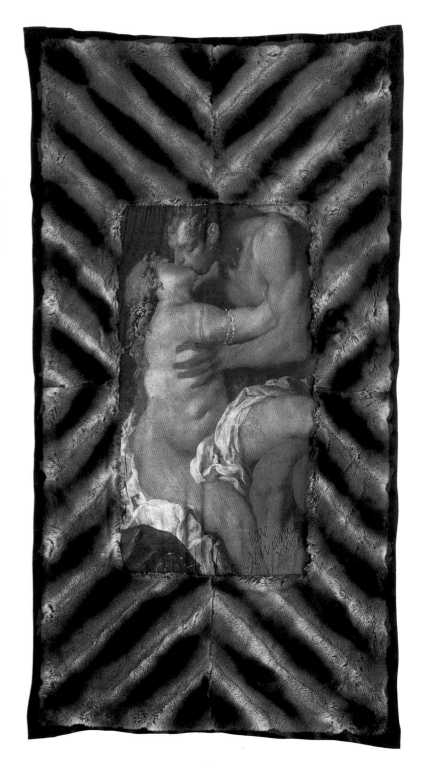

Wilke-Rodriguez

(USA)

SOMETIMES
WHEN WE THINK OF YOU
WE CRY

SOMETIMES
WHEN WE THINK OF YOU
WE CRY

SOMETIMES
WHEN WE THINK OF YOU
WE LAUGH

SOMETIMES
WHEN WE THINK OF YOU
WE LAUGH LOUDLY

SOMETIMES
WHEN WE THINK OF YOU
WE CAN'T BELIEVE YOU'RE GONE

SOMETIMES
WHEN WE THINK OF YOU
WE JUST CAN'T BELIEVE YOU'RE GONE

OH
HOW GREAT THE POWER OF LOVE

In memory of Terry Wilke

I met and fell in love with Terry Wilke in the summer of 1989 on Laguna Beach, California. He was my lover, my friend, and my teacher. The things I miss most about Terry are his smile, that laugh, the sparkle in his eyes, and his great passion for life. Terry believed that you should be passionate about everything you do in life. He was the kind of person who inspired you to do your best.

I made Terry's panel with the help of his business partner and friend, Eddie Rodriguez, and the Wilke-Rodriguez staff. It was truly a "family" effort, a labor of love that made us all remember and rejoice in Terry's indelible impact on those who knew him. Making the panel gave us a sense of purpose at a time when we all felt useless.

AIDS and the deaths of Terry and other close friends have left me emotionally numb and at times not so passionate about life. I try hard not to let the epidemic rule my life, but sometimes it can be overwhelming. I know Terry would want me to move forward and stay passionate. That was his gift to me, and that's how I try to live my life.

Thank you, Terry. I love you.

SCOTT MCBEE / LOVER

Workers for Freedom

(UK)

In memory of Richard Dawson

Richard was our good friend, and we miss him. It's like he is away on a long holiday. Richard always sent lots of postcards, thank-yous for dinner, hellos from holidays, observations on life, so we thought the base for the panel should look like a postcard. Since he loved black and white photography, we did it in monochrome.

We scattered half of Richard's ashes in Mykonos, on a cliffside overlooking his favorite beach. The background represents the peacefulness of that place. Not wanting to monopolize his memory and remembering how Richard loved flowers, we asked some of his friends to make flowers for the quilt. On April 7, 1994, they brought the flowers to our studio, where we all put them into position. We stitched the flowers around his name. With love.

RICHARD NOTT / GRAHAM FRASER / DESIGNERS

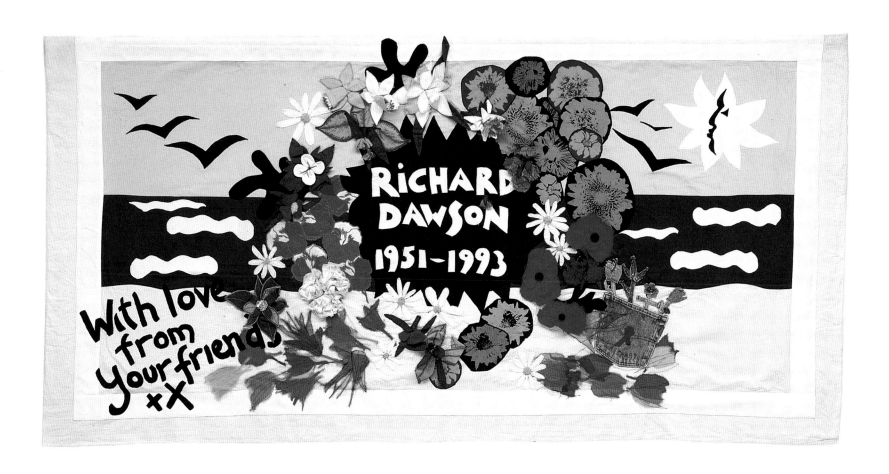

The NAMES Project Foundation sponsors and displays the AIDS Memorial Quilt to raise awareness about the epidemic, to ensure that those who have died are never forgotten, and to help bring an end to AIDS.

For information about making a panel for the Quilt or about upcoming Quilt displays, please contact:

The NAMES Project Foundation

310 Townsend Street

Suite 310

San Francisco, CA 94107

415-882-5500

http://www.aidsquilt.org

THE NAMES PROJECT

AIDS Memorial Quilt